The Natural World
in Watercolour

To my son Antonin, who has given me so much.
To my students.
The artist's works can also be found on the website:
http://monsite.wanadoo.fr/aquaseine/

First published in the UK in 2010 by
New Holland Publishers (UK) Ltd
London • Cape Town • Sydney • Auckland

Garfield House, 86–88 Edgware Road, London W2 2EA
www.newhollandpublishers.com

80 McKenzie Street, Cape Town 8001, South Africa
Unit 1, 66 Gibbes Street, Chatswood, NSW 2067, Australia
218 Lake Road, Northcote, Auckland, New Zealand

Original title of the book in French:
Aquarelle la voie de l'eau
© Groupe Fleurus, Paris, October 2008
Copyright: October 2008
Published by Groupe Fleurus, Paris, France
Photo-engraving: IGS
Published in Spain by Gráficas Estella
ISBN: 978-2-215-09437-1 1st edition. Edition no. 94043
Translation © New Holland Publishers (UK) Ltd, 2010

ISBN 978 1 84773 695 6

For Fleurus
Editor in chief: Christophe Savouré
Editor: Guillaume Pô
Editorial support: Valérie Monnet
Art directors: Laurent Quellet, Catherine Enault
Production: Anne Floutier
Photographs: Olivier d'Huissier
Page layout: les PAOistes

For New Holland Publishers
Editor: Amy Corstorphine
Translator: Barbara Beeby
Production: Laurence Poos
Editorial Direction: Rosemary Wilkinson

Printed and bound in Malaysia by Times Offset (M) Sdn Bhd

The Natural World in Watercolour

JEAN-CLAUDE CHAILLOU

NEW HOLLAND

Contents

A few words...

You probably already know that watercolour painting is an exacting discipline. But it's the feeling you capture on the paper rather than the technique that is important. In order for your work to be understood by the viewer, you need to develop strong, convincing methods for conveying that feeling.

Of all our senses, sight is the one that best allows our consciousness of the world to expand. Practise 'thinking big', going beyond the simple manifestation of things and opening up an internal world of our own. Then, as we convey on paper our impressions of what surrounds us, we reveal a sort of buried truth. We transform a few grams of coloured substance into a painting and create a whole new world.

Contrary to what you might expect, a painter's main handicap is their sensitivity, as it can make you less receptive. Trying to make sense of your dreams, for example, isn't easy as nostalgia and memory tend to mingle together. A true artist, however, puts aside these emotions and is able to relate to the pigments he uses, and to show the timelessness of nature, free and unbiased. In doing this he has an opportunity to extend life, to eradicate time. For art is the knowledge that makes it possible to prevent flowers from fading.

Jean-Claude Chaillou

Iris escaped from a gard

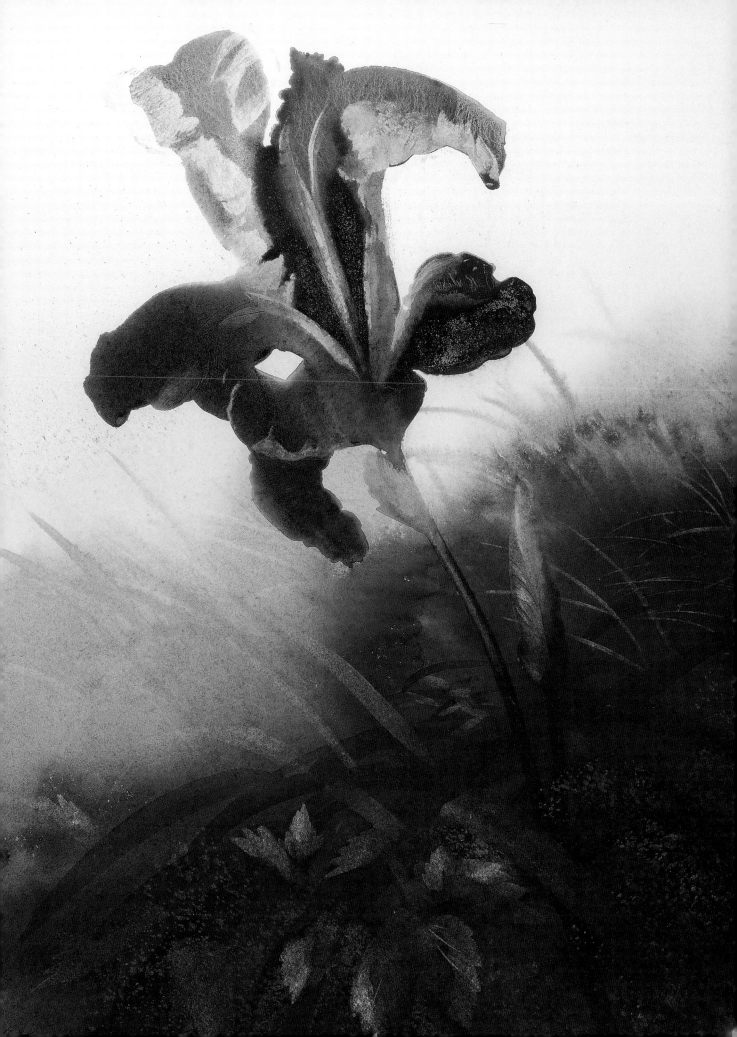

The painter's art

A good picture should capture and hold a viewer's interest for as long as possible. A painting should also be read and, by learning to read it, the viewer will have a better understanding of what impression the artist intended to give.

It isn't surprising, then, that creating a painting requires very careful thought. The artist needs to consider composition, layout and execution, the development of the different elements, whether the proportions of all the points of interest are correct as well as which colours to use.

The pale iris (detail)

Successful water colouring

Before you start

If we see something beautiful in nature - a landscape perhaps - it is natural to try to convey it as effectively as possible to allow others to share in that feeling too. Painting is not an accumulation of tricks, systems and formulas to convey this feeling, but they certainly do help, and the skill of these techniques will determine whether or not your watercolour is interesting. A so-called 'spontaneous' pictorial expression can often be no more than the reflection of a momentary inability to do any better. Sometimes the result is a dynamic work which may, in fact, be pleasing to look at, but creating something that is really beautiful takes time. It is, therefore, so important to take time to stop and think before starting your painting.

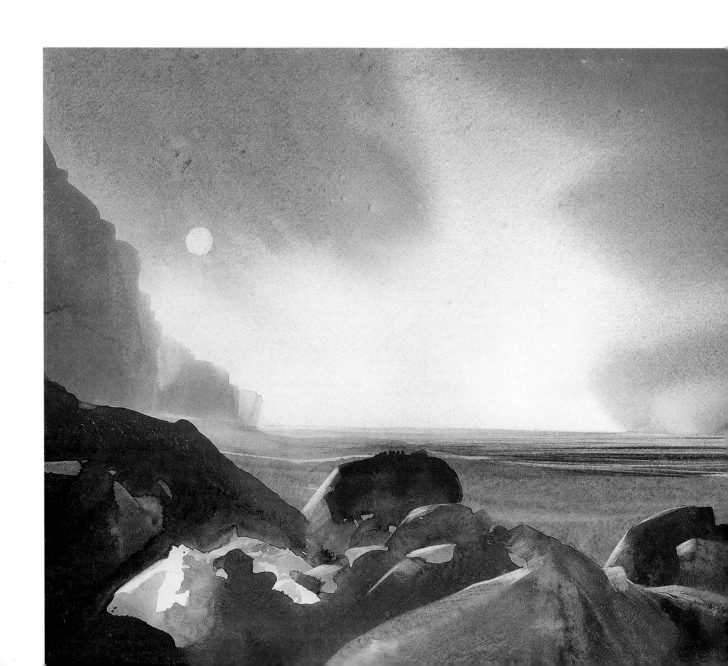

Painting method, painting style

For a painting to be interesting to look at, a number of elements need to be considered. Firstly, the quality of the paper is very important and, ideally, its texture should be preserved as much as possible. The ways different pigments work together in the water should also be taken into account. However, the technical aspects of painting is what should be focused on most carefully. In fact, the techniques used in the painting need to be so unobtrusive that it gives the impression of almost having not been painted at all.

If it is obvious that a long time has been taken over a piece of work – the hesitations, the second thoughts, the regrets – a viewer may not look at it in the same way. A watercolour that makes you forget it has been painted at all, however, is a true work of art. That is where the magic of the art lies: if a painting is not fantastic, it may as well not exist. But it is not enough for just the tecniques used in a watercolour to be faultless. 'Painting method' should not be confused with 'painting style'. Painting method relates to the way the artist does not allow us to forget that he is the creator of the picture. Yet, painting style relates is the way the painter makes us forget that he is the creator of the picture.

Searching for feeling

As an artist, your choice of subject is very important. After all, how can you paint in a setting that has no emotional effect on you? The feelings that a landscape can evoke are a recognition of the external world by our internal consciousness. They come from something inside us that cannot be questioned and is linked to our objective consciousness. These feelings work on the concept of 'global perception', which describes the common way we feel when we see something. The question is though, how best to convey the subjects that move us. Feelings are not rational and what attracts us to paint something can't be controlled. A captivating landscape simply invites us to stop and give it another life on paper, to offer it an alternative existence.

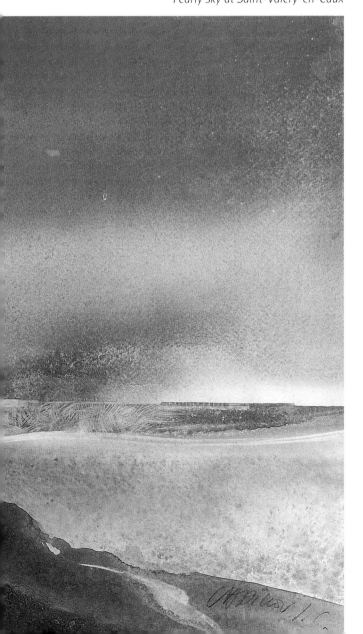

Pearly sky at Saint-Valéry-en-Caux

Reflections on the art of composition

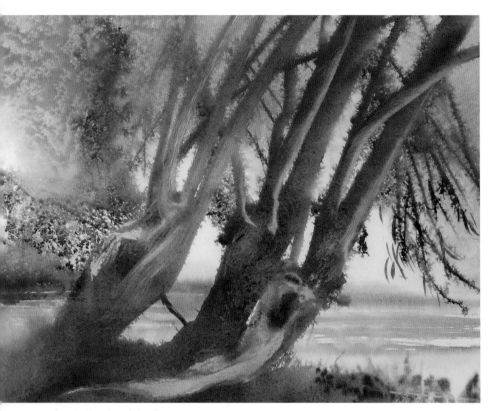

On the banks of the Epte

Centres of interest

You can often find several centres of interest on a river bank and because of this, they sometimes conflict with each other. At first glance the eye is drawn to a brightly lit area as we are attracted, to a greater or lesser degree, by light. It could be a gap between the trees on the bank revealing the other side of the river, for example. At second glance, the eye turns towards a shady area that could be a faint path worn by the fishermen dispersed along the river. Here, the shade provided by the protective barrier of trees is equally welcome to the eye. To leave is to venture into the unknown whereas to stay in the shade is to choose the protection of a familiar world, which creates a paradox for the eye. It is important to be aware of this in a painting and to emphasize it for the pleasure of the viewer.

Visual developments

To avoid 'locking' the eye in by making things too obvious, it's a good idea to create one or more vistas by unfolding visual developments. The viewer's attention will then be able to move back and forth between the different areas of interest in the painting for as long as they hold their attention.

In this example the eye can follow a number of developments: the path going off to the left, the source of the soft light coming from the right, the tops of the trees and the opposite bank of the river glimpsed in the distance. A path along a river is seldom maintained and is marked only by occasional traces of passers-by. So here the path will only be 'hinted at', to emphasize its natural, almost hidden, aspect. The left side of the composition evokes ideas of a different order: protection, the familiar, the cocoon. This impression is created by the protective barrier of old trees with their roots deeply embedded in the earth. Most of their branches reach out towards the illuminated side of the picture and guide the eye towards the top right, where the light source is. The branches are lit from below by the reflection of the light on the water. To some extent it is this light that places the scene, unmistakably, on a river bank.

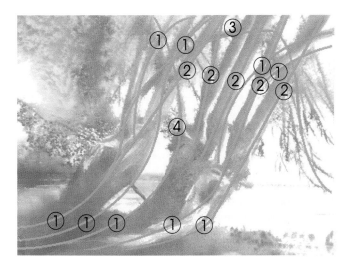

Page layout

① The strong lines almost all lead towards the right.

② Five oblique lines bring light visual relief to the drama.

③ One single curved line nonchalantly crosses the composition and drops down to the right unencumbered. It is reminiscent of a willow tree.

④ A counter curve visually supports curve 3. Stronger than curve 3, it crosses the composition and takes root on curve 1.

Presentation

The very strong contrast in this picture shows where the light comes from and how it is distributed. Opposite the large open area of light coming from the right there is an exit route. As a result the work is not 'directive'. The eye is guided towards an element beyond the picture, offering a subjective opening to the viewer's subconscious.

The interplay of textures and colour

One of the most exciting aspects of watercolour painting is finding clever ways of producing a meaningful piece with maximum efficiency and in the least possible time. A great strength of watercolour is how successfully energy can be recreated; the life of plants and the power of a topography, for example.

Whether it be the bark of a tree, the furrows in a field, some foliage or the reflections in a river, you can take great pleasure in finding a way of showing the different elements

of the subject, as here with the worn bark of these old trees. The monochrome greys chosen for this picture are slightly reminiscent of old, rather faded photographs. The different shades of grey are achieved by simply mixing four colours on the palette: crimson lake, Armor green, ultramarine blue and burnt sienna.

●●●●● The subjective view of the painter

Example of a subjective view

To approach the notion of the subjective – or internal – vision of the painter, we are using a subject designed to create nostalgia. Running along this railway bridge at Danu was a line that joined Gisors to Vernon. The line had not been used for over twenty years when I did a drawing and a watercolour of it. A subject like this is easy because the rails guide the eye towards a point which is extremely controlling and fixed, 'locking' the eye in. The objective interpretation of the rails leads one to think of transport, whereas when looking at the painting – which shows the artist's subjective vision – the viewer may think of travelling and my associations with that. By appealing to their imagination in this way, you are not just showing an interpretation of the scene, you are inviting someone on a journey.

This photograph shows the objective view of the subject

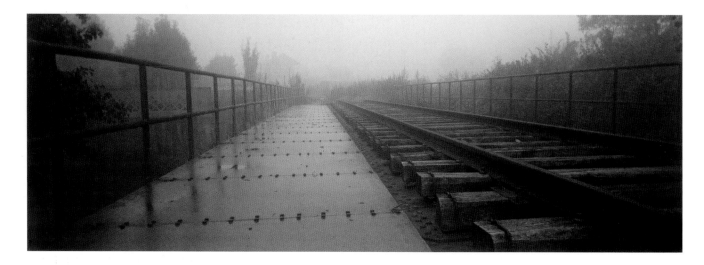

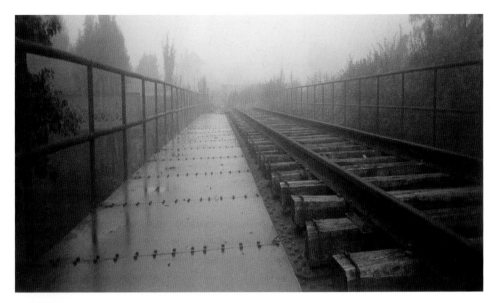

This version of the photograph shows the objective reality used for the proportions in the drawing and the watercolour below.
It's easy to see the difference between the reality and what my subconscious mind felt.

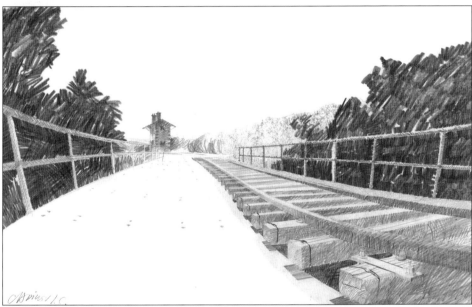

The preparatory drawing, made in situ using Conté pencils, allowed me to explore this idea and to develop my subjective view of the subject.

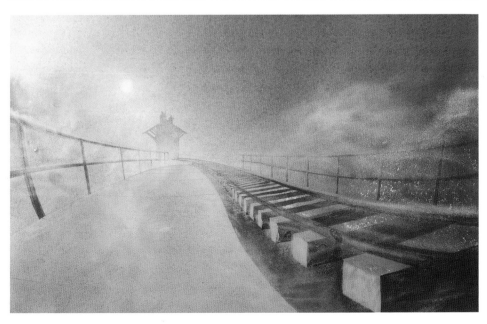

The watercolour is the synthesis of my view of the subject. It shows the inventiveness I had to use to get away from the extremely rigid and directive aspect of the objective reality. The watercolour shows how I translated that objective reality. My brain 'processed' that reality and passed the result on to the viewer.

Feelings provoked by the subject

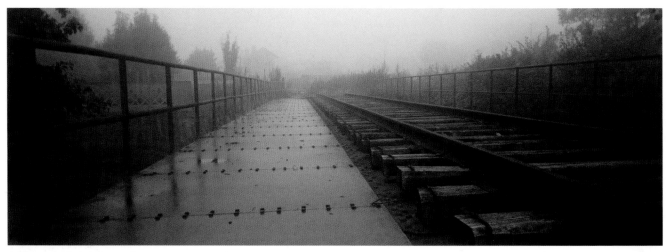

A photograph is supposed to represent the objective view of a subject, since the image passes through the objective lens of a camera.

By giving my drawing the same proportions as the photograph I reveal the objective perception I have of the subject. My objective view makes me interpret the reality, emphasizing the heaviness, oppression and sadness. This feeling, which is uncomfortable and unsettling, prompts me to modify the reality later in the hope that it will make others feel more comfortable.

If the viewer likes my watercolour, it is because something subjective attracts them.

Their imagination has stepped into the objective view they have of the world.

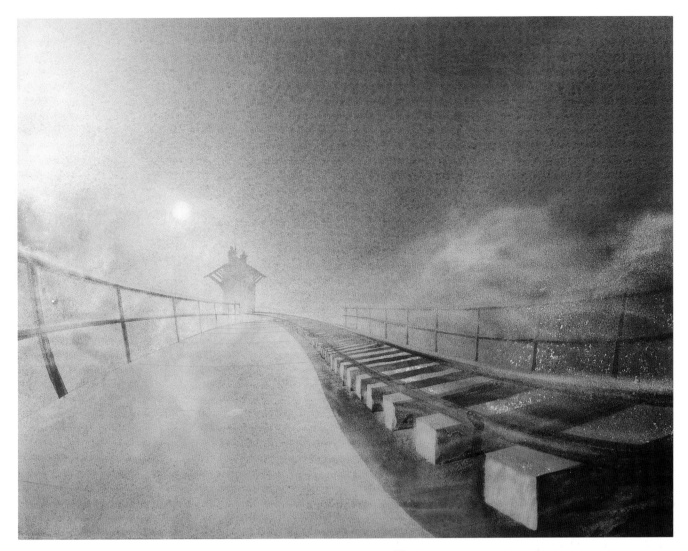

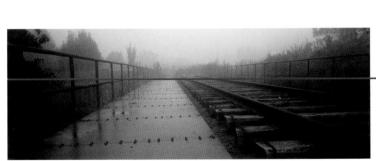
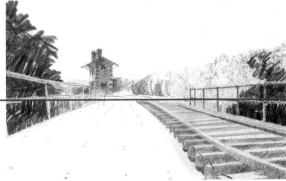

The line corresponds to the horizon

In the drawing I have expanded the space at the top, giving almost three times more space to the sky. Also, the space occupied by the horizon line at ground level has been drawn out almost one and a half times larger. Of all our senses, sight is what expands our consciousness of the world the most. Practising seeing the world on a grand scale can make us notice things on a grand scale internally. The objective world, in which nothing has a permanent form of existence, gives rise to our subjective impressions and, to convey these impressions, an artist should try to go back from the manifestation of things to their concept. By introducing softness through the use of curves, I have changed the rigid directive lines according to the main principles of perspective. For a landscape painting to make the viewer feel like they are a part of it, its construction must follow the rules that we universally recognize and go beyond those of just colour.

●●●Colours

The use of pigments

Watercolour painting involves taking a large amount of water, into which you drop pigments that interact with each other and set off actions that the artist can use. But watercolour painting does not necessarily mean painting with watercolours. Although I am a watercolourist, I also use extra fine gouache. With more 'body' than watercolour, it enables you to play with the creaminess of the pigments while retaining the same fluidity. On the paper, it allows for smooth lifting out and removal in dry, moist or wet conditions.

To see this for yourself, dilute some extra-fine ultramarine blue gouache on your white palette using a good amount of water. Spread the colour out and leave it to dry. Do the same with some ultramarine blue watercolour from a tube or a pot and then compare them. You will see that the colour of the gouache is more powdery and much more dense. In fact, every pigment has its own characteristics and reacts differently depending on whether it is alone or mixed with another. I use the following colours:

Lemon yellow is ideal. It blends with all colours perfectly. It is the lightest of all the yellows and does not contain any white.

Persian red light leans towards orange and does not precipitate. Beautiful violets can be obtained with visual blending.

True carmine red. I use this bright red for painting flowers and fruits. You can clearly see some violet in this colour, particularly in the outlines of shapes washed with this red.

Ruby red deep is an alluring red. It gives shades that tend towards violet like true carmine red, but a touch of orange makes it warmer. I use it in blends for certain plants and tree trunks.

Carmine lake is a beautiful red which also has a touch of violet in it, depending on the amount put on the palette. Mixed with Armor green, it allows you to create a range of browns and greys quickly. It does not precipitate and dries quite quickly on the palette.

Persian violet. This pigment breaks up when dilluted and causes blue to appear in the outlines of the shapes it touches. It can be really useful for painting flower petals, for example. I sometimes also use it undiluted.

Ultramarine blue deep has a strong precipitate. It is a heavy pigment that drops onto the paper very quickly. When it is saturated it becomes powdery as it dries, so it is difficult to apply a glaze over this colour. I use it as much for its 'substance' as for its colour, mixing it with other colours to paint a forest in the distance or a stormy sky, for example.

Cerulean blue is quite a bright blue which I use almost exclusively in mixes reserved for skies, as it does not form any precipitate.

Cobalt blue has a lighter precipitate than ultramarine, with a slightly oily aspect. Mixed with other colours it is ideal for representing certain types of sky, for conveying grass covered with dew in the early morning or the dusty appearance of dry plants.

Blue ash. I use this blue for shadows, mixed with other colours.

Armor green is a very cool green, close in colour to emerald green. Unlike the latter, it does not form a precipitate and does not 'foam' when diluted. Mixed with carmine lake, it gives an interesting range of greys.

Cypress green. I often use this, mixed with other colours, to represent plants. It doesn't form a precipitate and reacts very well to contact with other pigments, except for ultramarine blue. When saturated, it tends to be shiny.

Earth colours and ochres are heavy pigments that drop quite quickly onto the paper. They do not adhere well in dilution and have a powdery aspect when dry. Beware of the undesirable halo effects that can appear with these colours. To make them adhere better, take a small jar of water, dissolve five lumps of sugar in it and use this water for working with the pigments. They will take longer to dry. An earth or ochre glaze of this kind must be applied as the final step in a painting.

Blue grey is quite a heavy pigment that drops quickly onto the paper. I use it highly diluted or mix it with other pigments. Its chalky appearance is an interesting quality to exploit.

Some observations on pigments

Pigments deposited in drops of 'mercurized' water

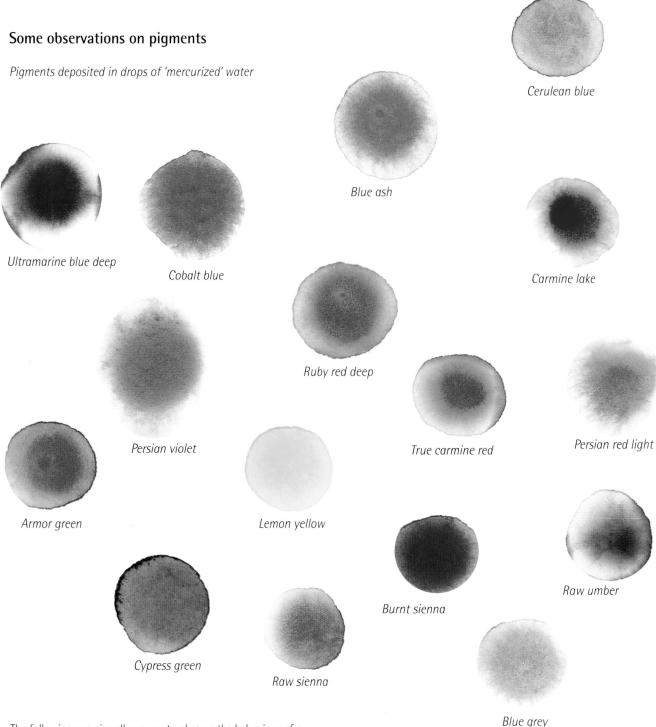

Cerulean blue

Blue ash

Ultramarine blue deep

Cobalt blue

Carmine lake

Ruby red deep

Persian violet

True carmine red

Persian red light

Armor green

Lemon yellow

Cypress green

Raw sienna

Burnt sienna

Raw umber

Blue grey

The following exercise allows you to observe the behaviour of a
pigment when deposited in two different quantities of water.

– Lay your paper, stretched on a frame (*see* p.32), completely flat
 on the table with the light source in front of you.
– Place a small amount of the colours listed on the preceding page
 on your palette with enough space between them to ensure
 they do not run into each other. Then place a large drop of pure
 water on each one to saturate it.

– With a no. 7 wash brush, put 32 identical drops of pure water
 on the paper. Each drop must 'mercurize', that is be rounded like
 a drop of mercury on a smooth surface.
– Using the same brush, take up the excess water from 16 drops
 on the paper so that half are moist. Leave the other half as
 they are.

Pigments deposited in reabsorbed drops of water

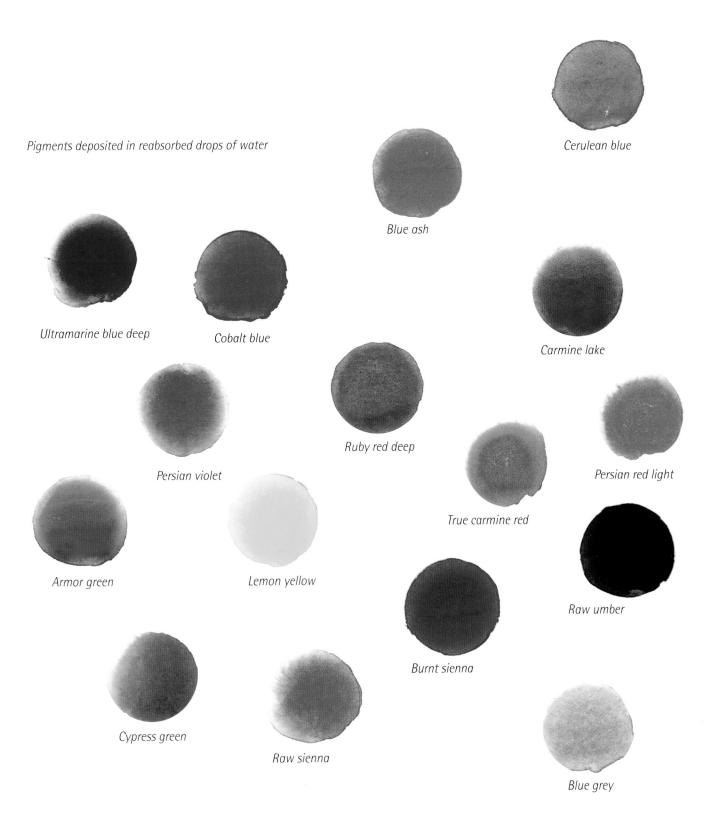

Cerulean blue

Blue ash

Ultramarine blue deep

Cobalt blue

Carmine lake

Ruby red deep

Persian violet

Persian red light

True carmine red

Armor green

Lemon yellow

Raw umber

Burnt sienna

Cypress green

Raw sienna

Blue grey

- With a finer brush, place a colour in each moist drop, rinsing the brush between each colour.
- Do the same with the 'mercurized' drops.
- Leave them all to dry.
- Note the reaction of the pigments: when the excess water is not removed, the colour does not go right to the edges of the drop of water and the pigments that accumulate in the centre make the hue darker.

So to work with watercolour when the paper is wet, it is essential to absorb the excess water before laying on the colour.

Organizing the palette

To paint with watercolour you need to learn how to gauge the weight of a drop on the paper and to anticipate how it will 'stick' when you tilt the frame. Rounded at first, like a drop of mercury, a single drop of water will pass through several phases before it evaporates. Good organization and confident movements will allow you to allocate more time to each step. This is why it is so important that the colour mixes on your palette must be prepared in advance and that you've got a sufficient quantity.

●●● **1** I have arranged four colours around the edge of my palette: lemon yellow, Persian red light, ash blue and cypress green. When mixed together in batches of two they allow me to obtain all kinds of hues. I then put some water between the colours using a sponge, so I can make large quantities of colour mixes. To do this, my palette must be perfectly horizontal (*see* Setting-up p.36).

●●● **2** In this example I will create the brown I'm looking for by working in stages. You must never mix more than two colours at the same time. Here I've started with blue ash and lemon yellow.

●●● **3** I then enrich this first mix by adding red to it.

●●● **4** I enrich part of the second mix by adding green until I get the colour I want. I can keep going back to the four basic colours as many times as I want to add them to the mix.

Tip
Mist your colours regularly with water to prevent them drying out.

Three apples and two pears

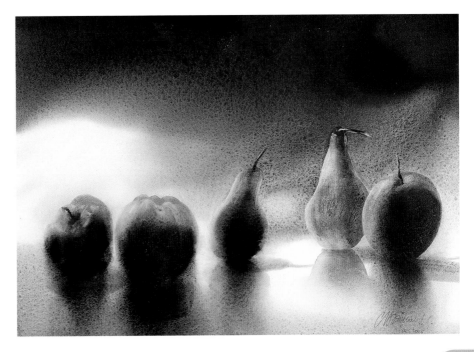

 # Brushes

Different brush types

Each brush has a very specific function. Laying water on paper and lifting colour out cannot be done with the same brush.

Squirrel hair wash brushes

To wet the surface of paper, lay colour on it and absorb the excess, a brush must be able to hold a considerable amount of water. The Kazan squirrel hair wash brush is the watercolourist's brush of choice, as it meets these requirements perfectly. Made by hand, it comprises three parts:

– The wooden handle, which acts as a 'floater' when the brush is dipped in a jar of water.
– The ferrule, which holds the bristles at the end of the handle. This is usually made from the quill of a bird's feather, but is also available in plastic. The ferrule has two bands of brass or iron wrapped around it.
– The head, which is made of squirrel hair, can hold large amounts of water and at the same time is good for detail.

The brushes I use most are a no.7 for laying on and taking up water and a no.3 for applying colour. I sometimes use a no.10 for large amounts of water and I complete the set with a finer brush, no.2-0. The larger sizes, the wetting brushes, are more difficult to clean, so use them for pure water only.

Sable brushes

The fibres of these brushes are very long so they don't hold much water and are not flexible. They are perfect for painting details with very precise, incisive strokes. A no.2 is all I need.

General brushes

For mixing colours on the palette I use a no.20 flat hogs hair brush.

I use a flat synthetic brush to create areas of light by lifting out colour, such as a no.12.

I also use a no.40 spalter brush. It's broad and rectangular, enabling me to wet large areas of paper, paint angular or geometrical designs and execute superb upstrokes and downstrokes.

Squirrel hair riggers

Their long fibres and very short handles give them great flexibility. They allow you to 'drag' a large amount of water over the paper and are perfect for creating long thin lines saturated with water which take longer to dry. Choose a mixture of different sizes such as numbers 8, 6, 4 and 2.

'String' brush

This brush is not commercially available but is easy to make. Take a 16cm (6 ¼in) long piece of hemp string, fold it in half and wrap a rubber band around the fold. The little 'sweeping brush' that you end up with is very useful for creating patterns of small branches between the leaves of trees or for representing certain types of grasses.

The clearing

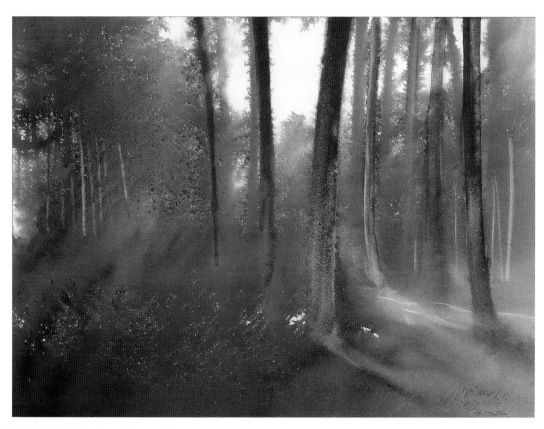

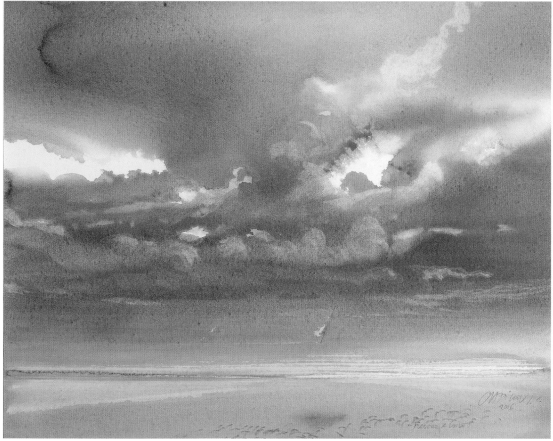

Windsurfing

Looking after your brushes

Clean your new wash brushes

Squirrel hair wash brushes are coated with gum Arabic to protect them. Before you use them, remove the gum with lukewarm water, holding the brush with one hand and gently rubbing the head between the thumb and forefinger of the other. Never store your brushes in a sealed container as the fibres may go mouldy and rot.

Water jars

Choose a transparent glass jar. Make sure it's tall enough so that when you put your brushes in the water they don't touch the bottom. They should float to stop the fibres from getting bent. Personally, I find a very large jam jar is best.

The water in your jar should stay clear for as long as possible. You take it from the glass jar mainly for mixing colours, not for washing brushes. To get good quality mixes it is essential for the water to remain clean.

Experiment with your brushes

Drop a wash brush in the jar of water, then take hold of it by the tip of the handle, lift it out of the water vertically and let it fall back into the jar. If you repeat this action several times in quick succession the head of hairs will splay out like a skirt and release some splendid bubbles. I love to hear that characteristic noise of the air, temporarily trapped, being set free. I often do this before I start a new watercolour painting because it puts me in the right state of mind, sensitizing me to the substance of the water, the light going through it and to my brushes.

Bottles of water

Squeeze the water out of your wash brushes

When you squeeze the water out of your brushes, the hairs must always lie in the same direction between the fingers so they are not damaged by getting bent. To do this, find a simple reference point to establish the angle at which to hold the brush. I use the metal bands holding the ferrule for this, systematically positioning them in the same way.

●●● 1 Place your left hand on a sponge (or hold it over the ground if you're painting outdoors). Hold the handle of the brush in your right hand according to your reference point and squeeze the head between the thumb and forefinger of your left hand.

●●● 2 Gently pull the handle back, pressing the thumb and forefinger together to squeeze the water out of the hairs, which will become flat like a spatula. Here the reference point you've established is very important, because the spatula formed must always be at the same angle in relation to the handle.

●●● 3 After it is squeezed out in this way, your brush can absorb excess water and colour.

There is no need to shape the head of a brush into a point. If you're using a good brush the point will form by itself. To find out whether a brush is good, dip it into the water, lift it out and tap the ferrule on the edge of the jar, turning it round as you do so. If it forms two points it is not a good brush. If it only forms one, take good care of it. You've got a good brush in your hand.

Cleaning your brushes

To clean your wash brushes when you're painting, use an atomizer of the kind you would normally use for misting plants. The procedure for removing the colour from your brushes is as follows:

For indoor painting

- Squeeze your used brush out over a sponge placed on the left hand edge of your board (*see* previous page).
- Do not dip the whole head into the jar of water, but place just the tip on the surface so the water can penetrate the bristles. Remove the brush quickly before any colour seeps into the water.
- Squeeze the brush out again over the sponge and repeat the operation several times.
- Finish off the rinse by swivelling the brush round like a 'skirt' in the jar.
- Then squeeze the sponge with the colour in it into a bowl on the ground.

For outdoor painting

Things are much simpler outdoors. All you have to do is rinse your brush with the atomizer, allowing the water to drip onto the ground.

When you've finished painting

When you're not intending to paint for a few days, clean your brushes thoroughly and rub the bristles on some soft soap or household soap. Leave them to dry in the open air with the soap foam on them. This will prevent insects from settling in them and mould from growing. Simply rinse them in lukewarm water when you're ready to start painting again.

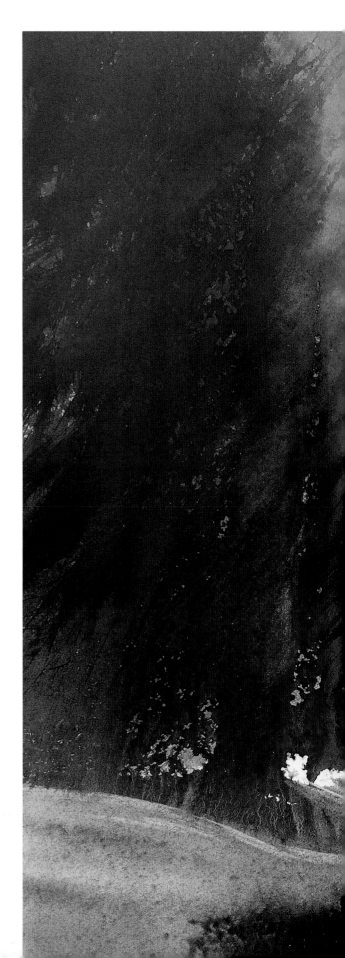

Avenue of Douglas firs no.1

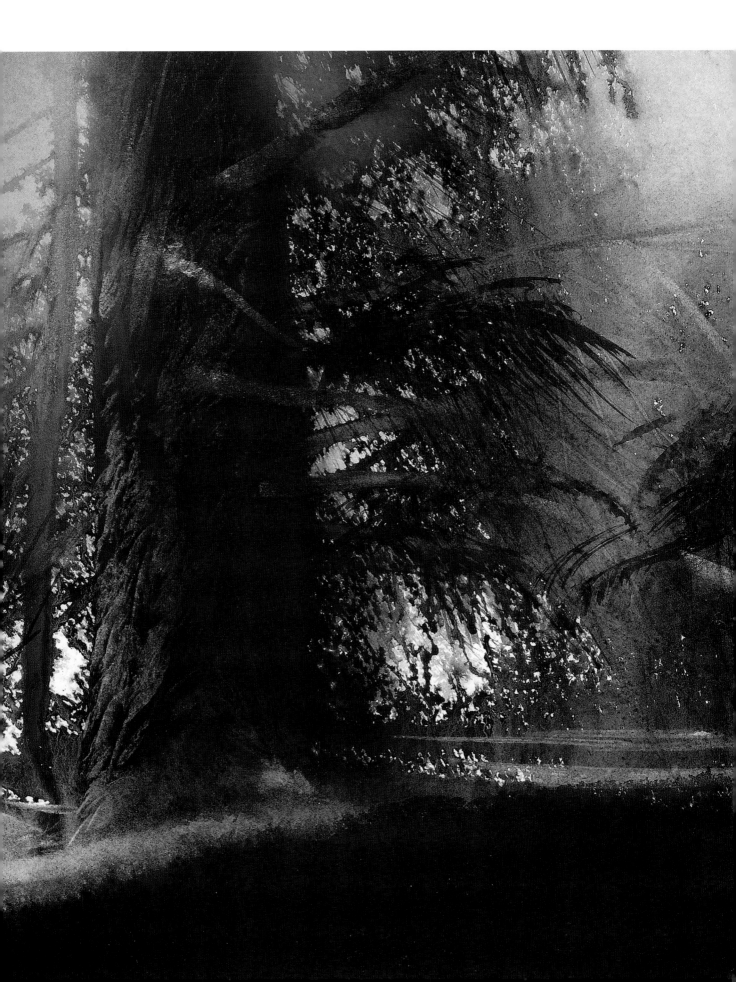

●○○ Paper and stretchers

Paper

Working in watercolour involves using a lot of water. If you put a fair amount of water onto a loose sheet of paper you will see it start to curl. You can only really paint in watercolours on paper that has been stretched. Stretched paper is wonderful. Stretching your paper is already part of the painting process.

Specialist shops have a very wide range of excellent paper for water colourists. However not all are suitable, and you would do well to try out several different kinds before making a final choice. I use 220g/m² (140 lb) fine grain Arches Fidélis paper measuring 50 x 65cm (approx. 20x26 in), which I stretch over a wooden board with the aid of adhesive kraft paper. My many years of experience have taught me to discount a good number of the papers available.

Coarse and medium grain papers cannot be stretched using kraft paper because the kraft paper only sticks to the textured parts, and the water in the hollows of the paper gets underneath and makes it come off. These types of paper have other flaws which are noticeable when colour is applied: heavy pigments fall into the hollows and the raised parts create shadows that project onto the light parts, which then become grey.

Some types of paper are not properly sized and form 'pellets' under the brush. Others are like absorbant kitchen paper and act like blotting paper, making the work impossible to control. Pigments in dilution also react badly on paper which is too smooth. I also advise against cellulose-based paper, paper which is too white and paper that weighs more than 220g/m² (140 lbs).

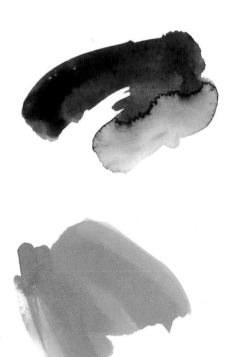

Colours applied to medium grain paper

Colours applied to fine grain paper

Stretchers

Paper can be stretched in different ways over a board or an oil painting frame. They all have both advantages and disadvantages.

Paper stretched over board using kraft paper

It is very useful to have a small surface available nearby to try out some 'touches' before you start on the painting. If you choose a board which is bigger than your paper you can use the edges for this. I stretch my 50 x 65cm (approx. 20x26 in) paper over boards of 60 x 75cm (24x30 in). This way of stretching paper enables you to use more heavy duty tools without fear of tearing the paper. When you've finished the watercolour you can retrieve your stretcher and stretch another sheet of paper over it. The disadvantage is the weight of the board you have to carry about, especially if you're painting outdoors.

Paper stretched over board and stapled at the back

The advantages of this method are the same as those described above. A watercolour done in this way does not need to be framed if it is protected with a coat of fixative. But if you want to paint the edge of the painting, or if you want to leave it unpainted, you will have to get a new board each time.

Paper stretched over an oil painting stretcher

This method enables you to spray the back of the stretched paper with water if it is drying too quickly. Unlike a board, an oil painting stretcher is very light. However, there is a strong risk of splitting the paper if you use a sharp tool. Also, it is impossible to put a stretcher like this on a tripod (*see* Setting-up, p.36), without the risk of tearing it. So you will not be able to paint with both hands free. A watercolour done using this method doesn't need to be framed, but here again you will have to change the stretcher if you want to preserve the appearance of the edge of the painting.

Willows under blue skies

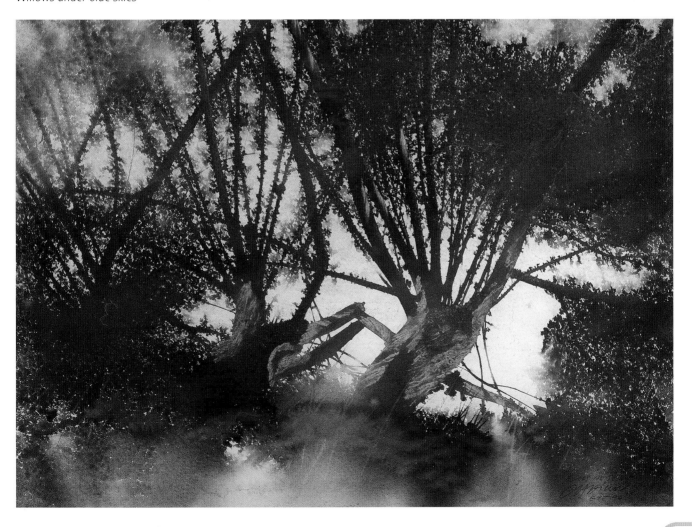

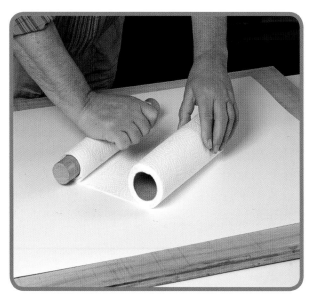

Stretching the paper

Materials required
- sheet of watercolour paper
- stretcher: wooden board larger than the paper
- roll of adhesive kraft paper
- rolling pin (or a 30cm/12in) wooden brush handle)
- roll of absorbant kitchen paper
- Atomizer filled with water and set to a fine misting (if the kraft paper does not have sufficient adhesive, add a tablespoon of wallpaper paste to the water)
- plastic tray larger than the paper (or a shower tray filled with water, all traces of soap removed, plugged with a flat rubber plug)

Make your 'absorber' roll by rolling several sheets of absorbant kitchen paper, still joined together, around the rolling pin.

●●● 1 Prepare your stretcher

To begin, position yourself in front of a light source. If you are using a new board, sand down any rough parts and remove the resulting dust with a slightly damp sponge. Place the board flat on your work area.

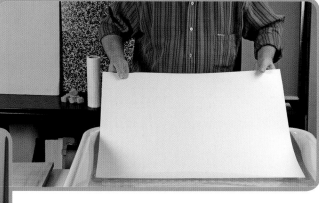

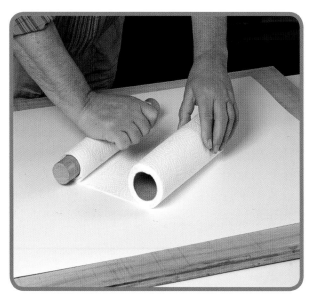

●●● 2 Soak the paper

Place the tray on the work area with the long side facing you and fill it with water. Take hold of the paper with both hands (fine grain side towards you) and slide it into the tray, 'slitting' the water. Press it down gently with the fingertips of both hands to immerse it fully in the water. The surface area of the paper will increase and it will become about 7mm (¼in) wider but it will not increase in length. Leave it to soak for 20 minutes, by which time the surface area will have reached its maximum size. The paper will tend to rise to the surface as it absorbs water. Push it down with your fingers spread wide to submerge it fully in the water.

●●● 3 Cut the strips of kraft paper

While the paper is soaking, cut the four strips of kraft paper you will use to stretch it on the board. Making sure your hands are completely dry, place the kraft paper roll at one end of the long side of the board and unroll it along the whole length. At the other end, twist it sideways and down to cut it against the edge of the board. Repeat the operation to obtain two strips the same length as the board and two the same width. Place them nearby in a dry place with the shiny (adhesive) side towards you. Put your kraft paper roll somewhere dry but not too warm.

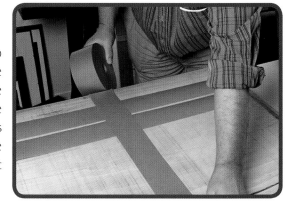

••• 4 Take the paper out of the water

When the 20 minutes are up, gently lift up the paper and start to roll it up on the surface of the water, taking care not to hold it too tightly as paper which is saturated with water is very fragile. Keep rolling it up until you have a cylinder.

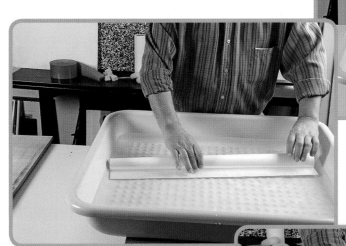

To prevent the weight of the water causing the paper to fall apart, lift the cylinder up, placing your right hand in the middle and your left hand at one end. Raise it gently out of the water, holding it at an angle.

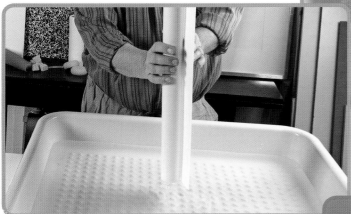

Hold it vertically over the tray for a few moments to allow the excess water to run off.

••• 5 Take the soaked paper to the board

Carry your cylinder of paper horizontally, holding it underneath and leaving a few centimetres unrolled. Stand in front of the board and stretch out your arms to place the unrolled edge of the paper a few centimetres from the top of the board, parallel to the edge. Then unroll the paper completely towards you (fine grain uppermost). If you need to reposition the paper, roll it all the way up, not too tightly, lift the cylinder off the board and reposition it.

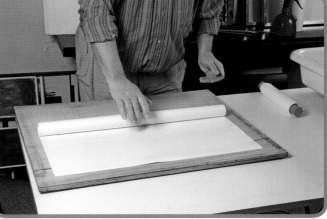

●●● 6 Absorb the excess water

Your wet paper will be shiny. Remove the excess water using the roller you made earlier with absorbant kitchen paper. Place the roller in the middle of the paper and roll down towards the bottom, applying some pressure as you go. Next roll from the middle to the top, then from the middle to the right and to the left. Still moving out from the middle, work diagonally towards each corner of the paper. Bend down so you can see the paper in low-angled light and continue to mop up the moisture until the paper is no longer shiny.

Tip
This mopping phase should be carried out quickly so that the paper shrinks as little as possible before being stretched.

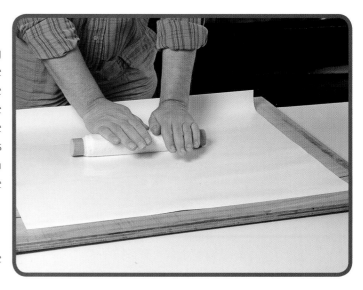

●●● 7 Fix the paper on the board using the kraft paper strips

The paper is fixed lengthways first, as it contracts widthways. Take one of the two long strips of kraft paper and stick it on, spraying the shiny side with the water and paste mix. To do this, hold the strip with one hand against a tiled shower wall or a protected floor, well away from the work area.

Once the strip is uniformly moist, hold it with both hands in the middle of the wide edge between thumb and index fingers, with the adhesive side and the index finger towards the floor. Hold it firmly and make it 'crack' three or four times as you stretch it out so the excess water or paste is removed. You can do this underneath the work area to avoid splashing your white paper.

Holding the strip taut, place it in the bottom left-hand corner of your board using your left thumb. Direct your eye to the opposite corner and lower your right hand to place the other end of the tape in the corner. For equal distribution of the tension the tape must be half on the board and half on the white paper. If your thumbs are correctly positioned in the middle of the width of the tape as you hold it, it will be perfectly positioned. Smooth the tape down with your thumb nail, from the middle to the ends, then with the edge of your hand to make it stick well.

Turn the board around so that the other long side is at the bottom and repeat the operation. Then, do the same for the short sides.

Drying

Prop your stretcher up to dry against a wall, away from any heat source. Although watercolour paper is thicker than kraft paper, it dries more quickly. If it is exposed to heat that is too intense, the paper will shrink before the adhesive has dried. To check whether the paper is dry, place the edge of your hand on the kraft paper. If it's cold you will have to wait a while longer before you start. If something has fallen on the paper while you're stretching it, do not rub it, in case it marks the paper. Wait until it's dry and gently brush the surface of the paper with a clean, dry no.3 wash brush.

If the paper separates from the kraft paper

When you're starting off you will find that the kraft paper often comes unstuck during the drying phase. Whatever the reason for this, you can retrieve the paper by cutting it along the edge of the kraft paper and stretching it again, even though it will be smaller.

There are a number of reasons why the kraft paper may come unstuck:

– There is not enough adhesive on the kraft paper (generally poor quality or adhesive has been badly applied). This is where a tablespoon of wallpaper paste in the water in the atomizer helps.

– There is too much adhesive on the kraft paper (the glue will behave like oil and the paper will slip as it dries).
– The stretcher has been left to dry close to a heat source which is too intense (see above).
– Coarse grain paper has been used (see p.30).

With a bit of experience you will soon get the hang of this essential stage of the work.

Removing the kraft paper strips

When you've finished your painting and it is dry, place the board flat on the table. Using a craft knife, cut around the edge of the paper where it meets the kraft paper and take out the painting.

To remove the kraft paper still stuck to the board, lift up a strip and pull to tear off as much as possible. Do the same on the other three sides. Then with a sponge soaked in water, wet the stubborn pieces of kraft paper and leave them for a few minutes to soften. Slide the blade of the knife underneath to lift them off. Wipe the board with a sponge and plain lukewarm water and scrape the surface with a scraper. Leave the board to dry.

●●●Setting up

The advantages of using an 'easel'

Water colouring is not easy. To be comfortable when you paint it is important to keep any obstructions to a minimum by adapting your set-up as specifically to this type of painting.

It's preferable to be able to use both your hands, not to have to use one to hold or support your stretcher. That's why I've developed a set-up adapted to my own method of working, which leaves both my hands free. The ideal position for the stretcher is, understandably, almost horizontal, given the quantities of water applied to the stretched paper. My 'easel' is actually a tripod of the kind that anglers use. When I'm sitting down my board rests on three points: my knees and the top of the tripod. So I can vary the slope of the stretcher by raising one of the tripod legs and wedging it against the leg of my seat.

Between dry and wet

Always position yourself facing the light source, both in your studio and outdoors, so you can see the action of the water on your paper and so as not to create shadows. Indoors, protect the floor from paint and water splashes as appropriate.

Position your seat in front of the light source and place the tripod in front of it, at your feet. The larger the triangle formed on the ground by the three support points of the tripod, the more stable it will be. Adjust the height so that when you are sitting down the top is slightly above the level of your knees. Place the board on your knees and reposition the tripod as necessary, so the top of it is underneath the centre of the board.

You are now going to arrange your equipment so that you are positioned between the dry and the wet materials.

Place the dry materials on a shelf on your left so that you don't have to bend down to reach them:
- tubes of colour,
- stiff brushes and brushes that are not soaking in the water jar (riggers and fine sable brush),
- various tools for creating texture (comb, small pieces of plastic and cardboard, plastic disc, paraffin wax, string brush, etc.),
- a roll of white absorbant kitchen paper.

Arrange the wet materials on another shelf on your right:
- a white palette and a brush for mixing the colours,
- a large jar of water with your wash brushes in,
- some sponges (near the jar).

Also have on the ground within reach:
- A bowl to drain excess water or colour into (especially when you are painting indoors),
- some sponges,
- an atomizer filled with water.

If you are left handed, arrange your set-up the other way round. Consider providing yourself with a large opaque, dark-coloured sunshade for outdoor work. It will protect you from the sun and bad weather and stop small leaves or dust falling on your paper.

Personalize your set-up

Choose a palette big enough to take a good amount of water and where you can make your colour mixes. Mine is made of simple white, smooth melamine and measures 62 x 50cm (24 ½ x 20in). Your palette must always be perfectly horizontal so the water and your colour mixes don't spill over onto the ground.

To balance mine I put it on an upturned dish (like that of a halogen lamp) topped with a round piece of polystyrene. I just have to press slightly on the palette to tilt the polystyrene and adjust the horizontality. This system is very practical in places where the ground is uneven such as under a tree or on a shingle beach.

●●●Light and shade

The interplay of contrast

Light is linked to shade. There cannot be light in water colouring without shadows. Light is provided by the white of the paper and it varies according to the quality of the paper. Because coarse grain paper creates shadows itself, it turns light grey and it is not appropriate for the fluidity of the water (*see* p.30).

Colour applied to fine grain paper

Colour applied to medium grain paper

Saturation of the chosen colours is essential when rendering light. If you juxtapose two pale colours with little contrast you will notice that the absence of contrast leads to an absence of light. The following examples show that there are different ways of bringing light into a painting.

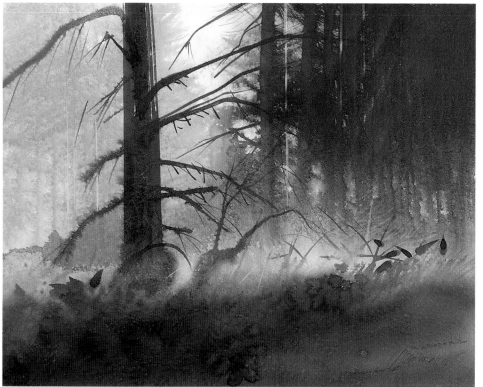

The master tree
The foreground with quite warm shades is in contrast with the light background with cool shades, which intensifies the luminosity and at the same time gives depth to the scene. The dark shades of the 'master tree' and the middle ground emphasize the forest's depth.

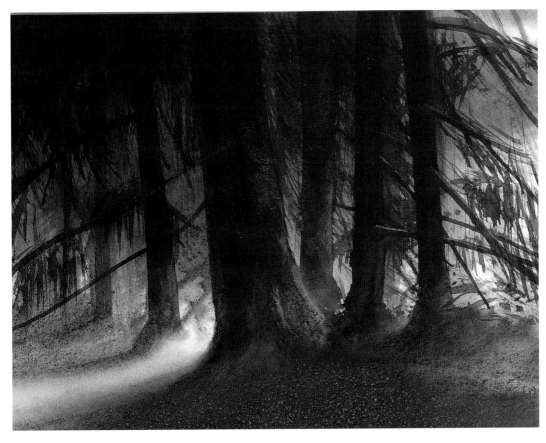

Avenue of Douglas firs no.3
Here, in the interplay of contrasts, the fading evening light shines on the ground between the trees, creating a mysterious atmosphere.

In the shade of a mountain ridge pine
In this example the contrasts are highlighted by the opposition of the sharpness of detail in the foreground and the softness of the distance.

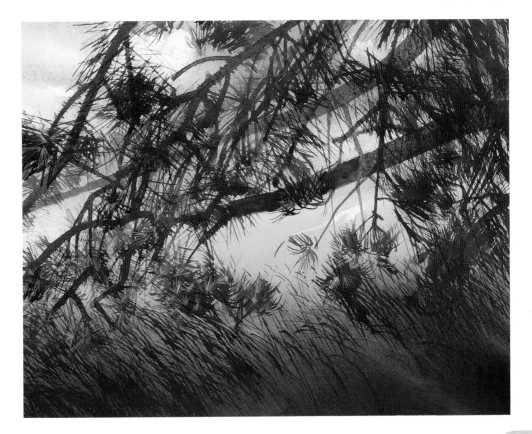

Values and shades

A gradation of values comes from one single colour which, depending on the degree of saturation, goes from the darkest value to the lightest. When you tilt your stretcher the colour spreads out, gradually getting lighter. A gradation of shades, on the other hand, comes from several colours (for example, from yellow to red passing through orange).

Children playing on the dried up river Loire
The gradation of values on the water brings light and perspective. The effect of perspective is heightened by the nature of the ultramarine blue pigment which fades as it recedes into the distance.

White table beneath five peaches
The association of the gradation of values in the background with the subtle gradation of shades in the reflections of the fruits on the table gives both strong light and depth to the scene through the contrasting elements.

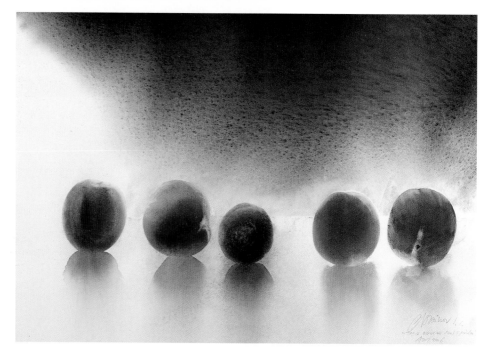

The interplay of complementary elements

Light can also be brought in through the contrast of complementary colours (yellow/violet, blue/orange, red/green). The colours may be light in one place and saturated in another. For example, if you put a green on white paper the eye will create a complementary pinkish colour on the surrounding white of its own accord.

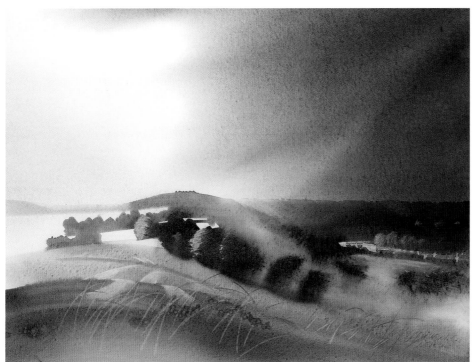

Storm over Haute-Isle
The gradation of values in the sky (saturated blue-violet), together with the application of shades in complementary tones (oranges on the left), brings strong light to this stormy landscape. The rather warm shades of green in the foreground complement the oranges of the sky on the left of the painting.

Willows under blue skies
A few branches highlighted with orange complement the dominant blue and bring in the evening light.

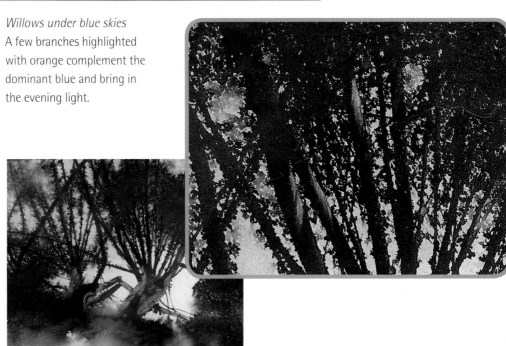

●●●Playing with water

Preparatory drawing

It is best not to do a pencil drawing on stretched paper before you paint. Watercolour applied over a pencil drawing has little chance of ending up as anything more than a simple colouring exercise. Also, if you erase the outline after you've painted you will make the colour lighter and the paper shiny.

If you erase it before you paint, the colour will stick to that particular place more. A drawing done with water, however, allows you to change your mind as many times as you like. If you make a mistake all you have to do is soak up the moisture and leave it to dry.

Dropping in and soaking up a drop of water

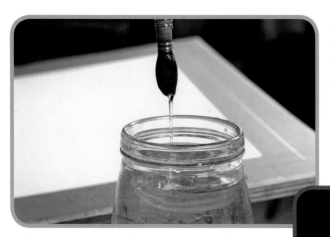

●●● 1 Wet your no.3 wash brush by dipping it in the jar of water. Then lift it out vertically, holding it by the end of the handle between the tip of your thumb and forefinger. Hold it a few centimetres above the jar and allow it to drip.

●●● 2 When it has stopped dripping, hold the brush horizontally with the ferrule over the jar.

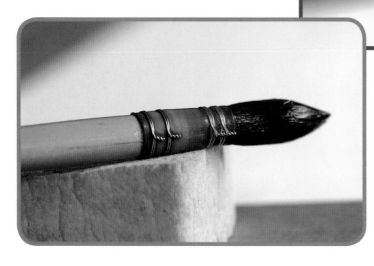

●●● 3 Check to see if there is still a drop of water hanging below the ferrule. If there is, place the ferrule on a clean sponge to absorb it. This is a good habit to get into to stop water falling on your work and creating an undesirable halo effect.

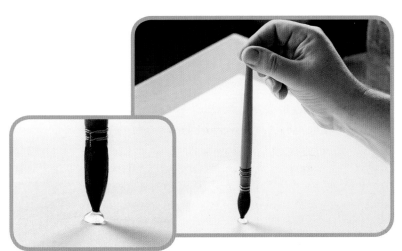

●●● **4** Still holding your brush horizontally, carry it to a position five centimetres above your stretched paper. Gently turn it vertically and lower it until the very tip of the brush touches the paper. A large, fat drop of water will fall on the paper. We describe this as the water 'mercurizing'.

●●● **5** Put your no.3 wash brush back in the water jar and take a larger wash brush (no.7 or no.10). Squeeze it out well and flatten it in the shape of a spatula (*see* p.26–27). Lightly brush the top of the drop of water with the tip of the brush. The drop will quickly be soaked up.

Do the same experiment again, but this time soak up the drop with your no.3 brush. You will notice it takes much longer to absorb. So when you paint, keep your large wash brushes for absorbing water or colour washes.

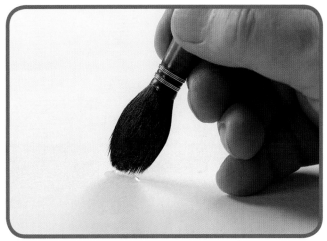

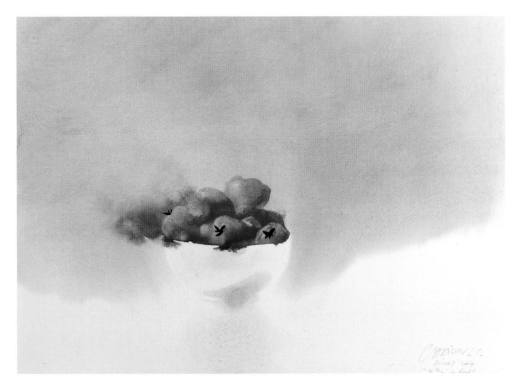

White bowl, red strawberries

Movement of liquids

You can control the movement of liquids on your paper by mastering the tilt of your stretcher. It's very easy, you just tilt the board by lifting your heels and wedging them against the legs of your seat (*see* Setting up p.36). The slope is then stable and both your hands remain free. Here is a simple exercise that will show you how to apply and circulate colour in a pattern drawn in water.

●●● **1** Place a small pool of water in the middle of your palette and put a few basic colours around it: yellow, red, violet, blue and green for example (*see* p.22). Dilute each colour by mixing it with water to obtain a smooth wash ready for use.

●●● **2** For the exercise to be a good test you need to draw a fairly complex pattern. Hold your board in a horizontal position. Take the largest of your squirrel hair riggers. Load it with water to its full capacity and begin to draw a spiral with several loops on your stretched paper.

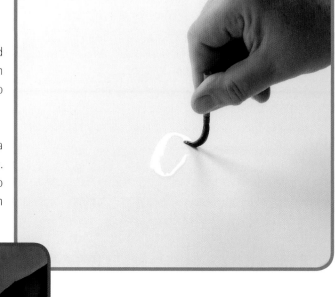

●●● **3** Add more water to the spiral with your no.7 wash brush as the design progresses. Continue to draw with the rigger and to add water with the wash brush to keep your design wet.

●●● **4** Draw some straight lines from the centre of the spiral with the rigger laden with water, to create a sort of spider's web. Make some of the lines extend beyond the edge of the paper into the kraft paper. Keep your board completely level while you work on this.

5 As soon as you've finished your design, add water with your wash brush so the design doesn't dry out and disappear.

6 When the water is uniformly rounded and glistening across the whole pattern, wait a few minutes for the paper in contact with the water to become properly wet and then take a clean sponge. Tilt the board very slightly towards you and place a corner of the sponge on top of the water at the bottom of the slope of the design to soak some of it up.

When the sponge is saturated, squeeze it out over a bowl if you're in your studio and begin the soaking up process again, continuing until the paper is hardly shiny at all.

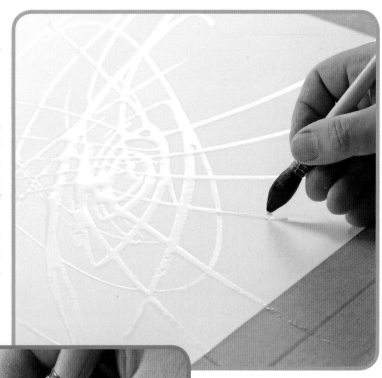

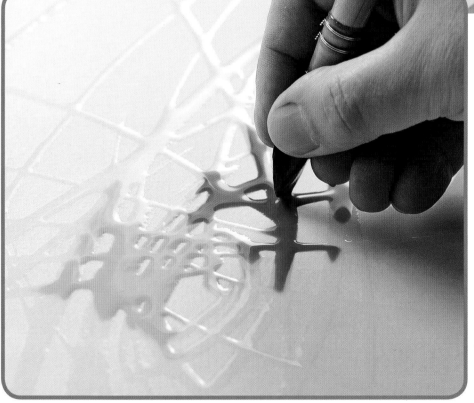

7 Your design is now ready to receive the colour. Take up the first colour on the palette (yellow) with your no.7 wash brush straight away. When the brush is loaded hold it vertically so the excess colour drips onto the palette.

Move it over to your water design, close to the most central line of the design, and squeeze it gently with your fingers to make it empty its contents into the centre of the design. You will find that the colour spreads quickly through the design. If you only want to put one colour on, tilt the board several times so that the colour rolls through the whole drawing. If not, keep your board horizontal and add some red on one side following the same procedure. Tilt the board to spread this second colour to the areas you've chosen.

●●● **8** Continue with violet, then green. Tilt the board so the colour runs out towards the kraft paper in the places where the pattern extends beyond the paper, and mop up the excess with a sponge.

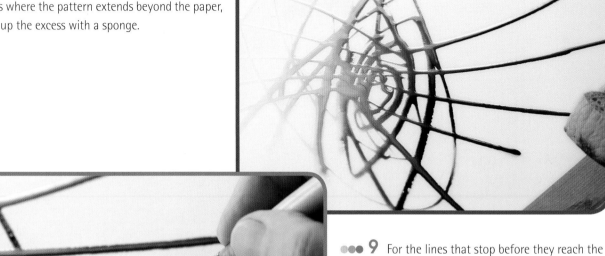

●●● **9** For the lines that stop before they reach the edge of the paper, absorb the excess colour using a paintbrush. You will see that a green circle (the last colour applied) has formed around the red-orange. This effect is useful for representing certain branches of trees or plants, for example.

●●● **10** Moisten the kraft paper with a brush to drain off the rest of the colour. Then leave it all to dry, making sure the board is completely flat.

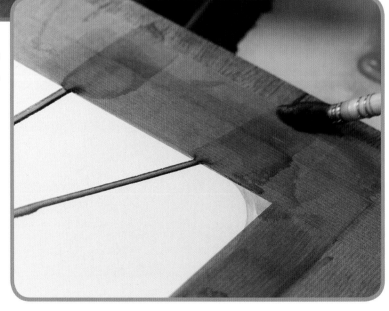

Notes
– The brush marks are not visible.
– You get a perfect gradation from the centre outwards.
– The quality of the paper is unchanged.
– The characteristics of each of the pigments have been brought out.
– The effects of the 'interplay' with water have been perfectly illustrated.
– Anyone looking at the work probably won't be able to understand the technical aspects of values and shades of the gradation, therefore lending a degree of mystery to your work.

Old willow trees at la Roche-Guyon

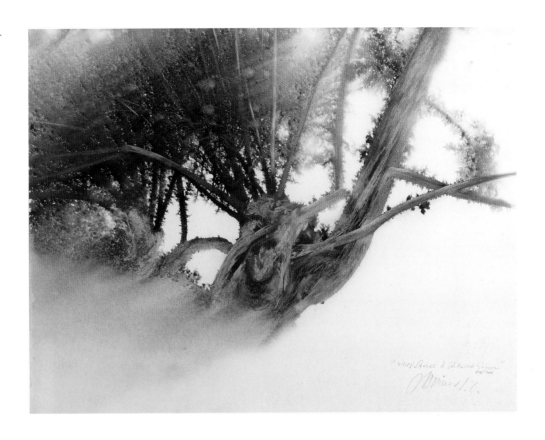

Handle

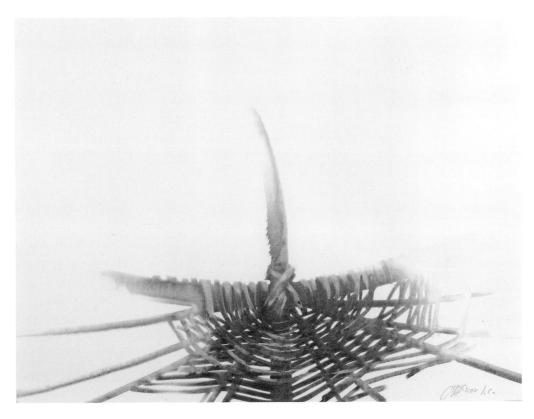

●●●Glazes

What is a glaze?

A glaze is a fine layer of colour laid over another previously painted dry colour, to create a completely different colour from the one obtained by simply mixing colours on a palette. This is useful as it is sometimes impossible to create some colours on the palette ('physical mix'), depending on the characteristics of the pigments. In such cases an 'optical mix', which is obtained by overlaying layers of paint, is much better.

For example, if you mix Persian red light with blue ash on your palette you will get a violet which is not ideal to work with because it's rather 'dirty'. But if you lay some blue ash on your paper, wait until the colour is perfectly dry and then cover it with a Persian red light glaze, you will get a high quality violet by optical mix. This type of mix is the most realistic for representing the natural world and, what's more, a glaze unifies all the different tones in a picture, giving an overall balance to the whole painting.

The simple glaze

A simple glaze has only one colour that covers part of the painting. It is uniform, as in this example of the sky…

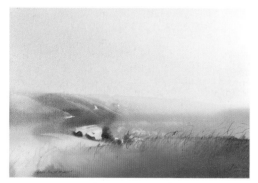

Misty panorama (see work p.112)

…or in gradation (progression of values) as in the upper part of this painting.

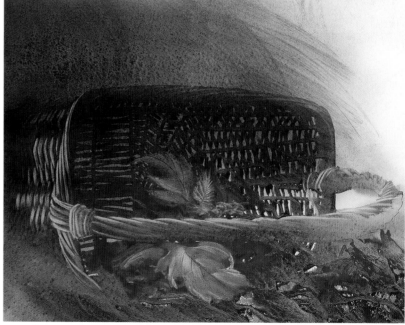

Basket in autumn

The glaze applied in several layers

The following examples illustrate the overlaying of several glazes. In general, you shouldn't overlay more than five colours, to avoid getting too far removed from the texture of the paper.

Make sure you lay ochre-toned washes on last. The capillary action in the dried powder of these pigments does not work well with clear applications on top, and this range of colours may fade with additional humidification.

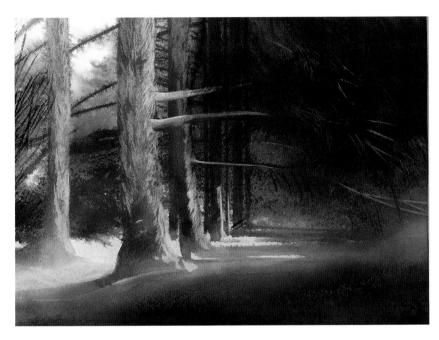

Avenue of Douglas firs no.7 (see work p.88)
Three overlaid glazes were used for the ground in the foreground, the last one being made up of warm tones.

Apples in the half-light
Here we also have three overlaid glazes. The first one is laid on the apples, the second (ultramarine) is laid on top and the third is the colourful grey of the background which also partially covers the fruits.

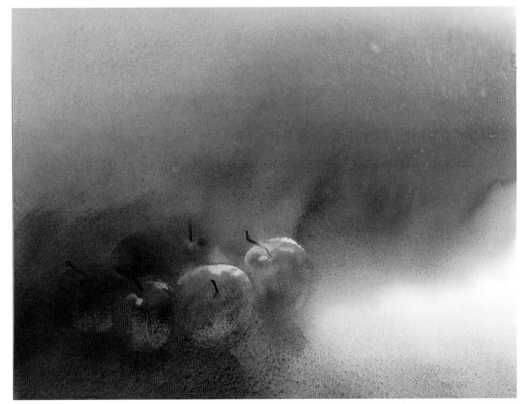

Drops of paint, halo effects and dark edges

Drops of paint

A drop of paint falling from the paintbrush onto dry paper need not be a disaster. The first thing to do is nothing. Don't rush to sponge it off, but take a moment to consider. What pigments is it made of? What colour has it fallen on to?

You can make use of an inopportune drop by changing its shape – or even creating others, if that's possible – with a view to incorporating it into the work.

A drop on the white paper

Do not try to remove a drop on the white paper with absorbant kitchen paper as this will cause the pigments to penetrate the paper. Cover it as quickly as possible with water to dilute the pigments. Then, with a fine wash brush (2-0), fade out the colour without exerting any pressure, absorb the moisture with a no.3 wash brush and leave to dry.

A drop on a dry glaze

Use the same procedure as above, but water down over a wider area in order not to 'whiten' the glaze.

A drop on a wet glaze

Take up as much of the drop as possible with your no.3 wash brush held vertically, lightly touching the colour. Then, very gently and carefully, blow through a straw to spread the rest of the colour into the surrounding moisture. Make sure your saliva doesn't fall on the paper too, however, as this would create an unfortunate halo effect.

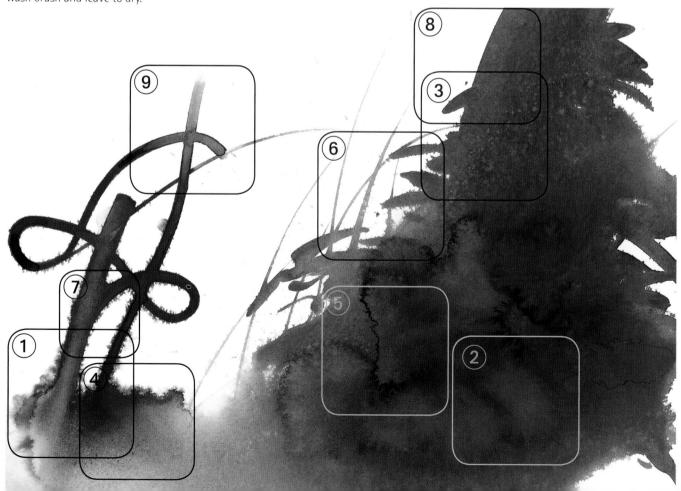

Halo effects

If you inadvertently let a drop of water fall onto an almost dry glaze you introduce an element that will soften the pigments and push them outwards. Relatively speaking, this is like a small meteorite falling on the surface of the moon. A hole is formed in the fresh paint, allowing the paper to show through, and the pigments are pushed outwards. An unintentional halo effect shows lack of control of movement and is detrimental to the quality of the work.

When you work with water, get into the habit of always checking to see if there's a drop of water hanging from the ferrule of the brush (*see* p.42). That is the most frequent cause of halo effects. But if, on the other hand, a halo effect is deliberate and adds something, it then becomes part of the magic of the work. Have some fun by deliberately creating some halos and experimenting with the effects they produce.

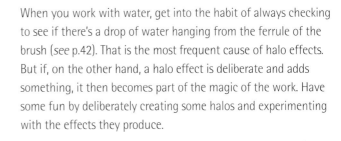

① *An unintentional halo effect*
Water has been dropped on a colour that was not completely dry. The pigments have been pushed out towards the dry parts.

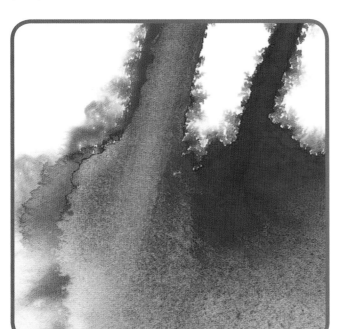

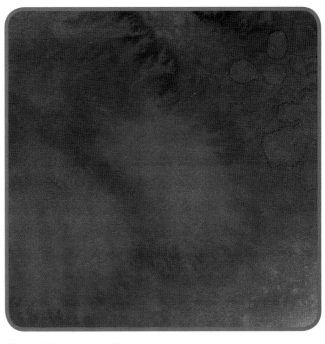

② *A deliberate halo effect*
A drop of water has fallen from a height into a fairly high level of humidity and a paint saturated with pigments. It's difficult to control, but you can nevertheless use this method to introduce some light into a dark area, for example.

③ *Another deliberate halo effect*
A spray of water droplets onto a wet colour can suggest small leaves in a tree, for example.

Dark edges

Dark edges appear on the borders between wet and dry and are caused by the saturation of pigments over a narrow area (like a line). You can put up with them or alternatively you can make them a part of the composition to represent something or obtain certain effects. This does, however, require a degree of practice.

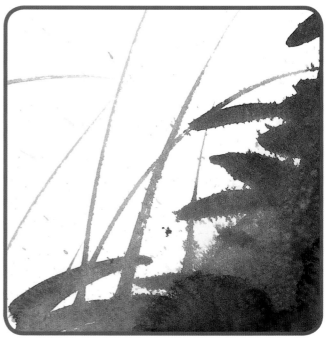

④ Unintentional dark edges
Water was introduced into the colour when it was not dry evenly all over. The colour that was still wet has faded.

⑤ Other unintentional dark edges
Some large drops of water have fallen into a colour that was still wet. The pigments have been separated and pushed outwards towards the edges of the dry area.

⑥ No dark edges
If you lay on only a small amount of paint and quickly remove the excess by tilting the stretcher vertically, you can prevent dark edges from forming.

⑦ Deliberate dark edges

Here a colour was laid on in a wet line and the edges were allowed to dry before more water was added along the centre of the line to wash it out. The wet line was also sprayed with an atomizer. The resulting gradation lends volume to the form. This allows you to convey the texture of lichen on old trees, for example.

⑧ Other deliberate dark edges

This is a sharply defined edge, produced when you leave an area of flat colour to dry without taking up the excess liquid. This type of edge can create a balance between the different planes of a composition, such as the outline of a tree with no bark in the foreground with a softer background behind.

⑨ Deliberate dark edges with progression of values and shades

Here a gradation of values was created with the first colour by tilting the board downwards to wash out the top part of the lines. A second colour was introduced into the first one when it was dry at the edges but not in the middle. This enables you to create a 'veiny' aspect in a design, when representing the stems of plants, for example.

●●● Lifting out and removing

Watercolour painting consists of both laying down colour on the paper and lifting it out. The impressiveness of the finished work depends on the skill of these two actions. The aim of lifting out and removing is to take colour off the paper in order to reveal areas of light or an underlying colour.

Lifting out
This technique is carried out on wet glazes using a wash brush. It's rather tricky work because it can only be carried out at a certain level of humidity or in the dry using a hard brush. The different procedures are described below.

●●● *With a rigger*
I do some lifting out with a moistened rigger in a glaze that is not quite dry. It's tricky work because halo effects can appear. You will need to try it out several times before you can be sure of success. It will enable you to represent grasses, for example. The process simply moistens and separates the pigments.

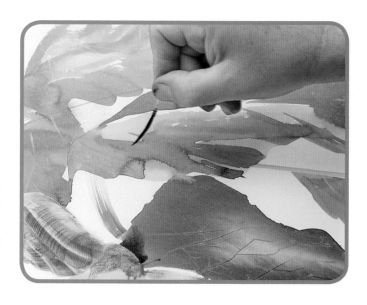

●●● *With a wash brush*
For this to work, the paper must have started to dry a little and have lost its shine. Squeeze out your no.3 wash brush and flatten it into a spatula shape with your fingers (*see p.27*). The colour can be lifted very precisely from the surface of the wet area by lightly brushing the paper with the sharp edge of the spatula. Colour can also be removed very precisely in the wet by dabbing the paper.

Note
It's very difficult to fully lift out from a wet ultramarine glaze. You will not be able to absorb all the pigment because it's 'heavy' and falls onto the paper very quickly. Only in a dried glaze can you lift it out using a hard hogs hair brush.

Removing

Removing is a more insistent action that consists of returning almost to the pure white of the paper to represent details in the light.

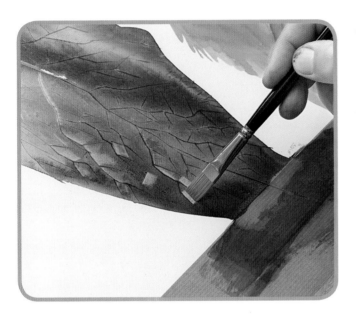

●●● With a soft brush

Lightly soak the fibres of your flat synthetic fibre brush (here a no.12 Kaërell) without wetting the ferrule, and pass it over your dry glaze, brushing the paper to remove the pigments. You can use the whole width of the brush or just the tip to remove a finer line. Use this technique to remove an unintentional dark edge, for example.

●●● With absorbant kitchen paper

I dab with absorbant kitchen paper to increase removal with a brush or to remove colour from a dry background, having first used a wet rigger.

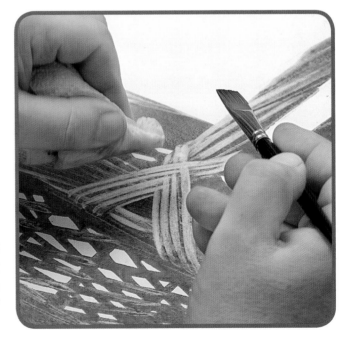

●●● Using a small piece of cardboard

I have sometimes just used the edge of a small piece of cardboard for quite precise or rectilinear removal of colour. Moisten it beforehand, position it on a dry glaze and wait a while for the pigments to soften. Then remove the colour with a piece of absorbant kitchen paper twisted into a point.

The paintings, step-by-step

Painting cannot represent constantly changing reality because that changing is the expression of life itself. Painting from nature is simply an attempt to capture that moment in time which will never be repeated, for nothing has a permanent form of existence.

Yet copying another painting is not what art is about either, so you shouldn't try to make an exact copy of the step-by-step paintings I do here. I couldn't even do that myself, in fact, and that's how it should be. By giving it a go and learning how to correct your own mistakes, you will develop a way of working with watercolours appropriate for your own style and interpretation.

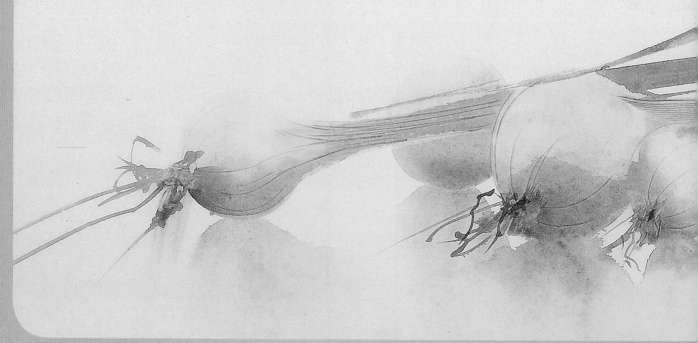

Spring onions (Scallions)

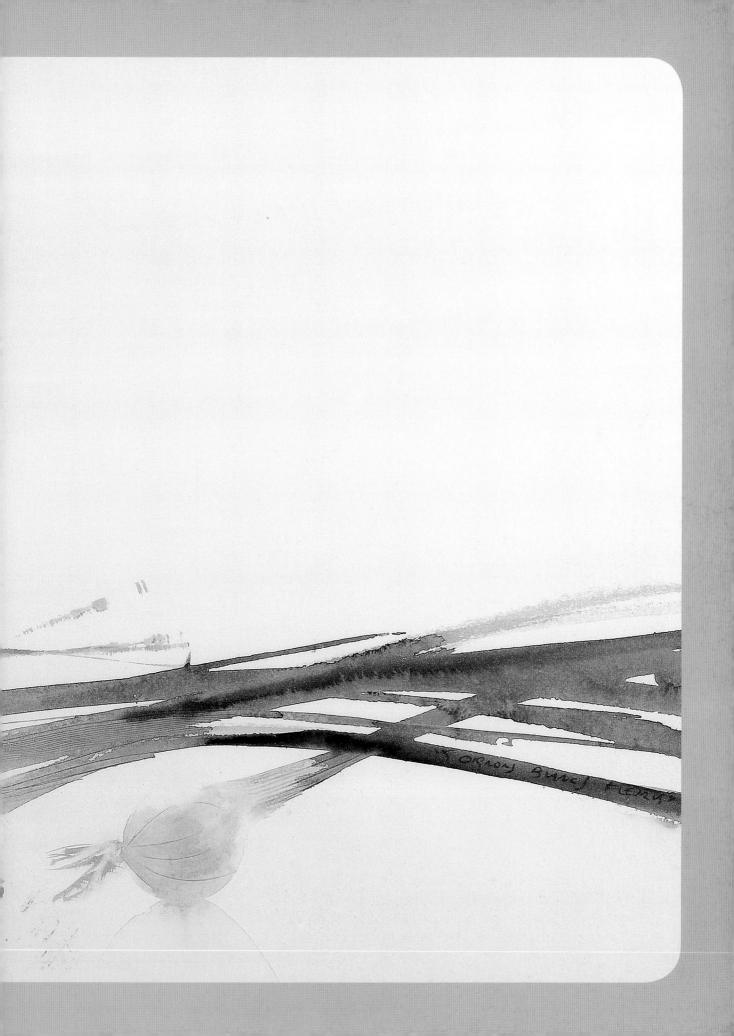

Spring onions (Scallions)

A successful watercolour sometimes rests on the balance between stillness (the onion bulbs) and movement (the green stems). The light falls on each of these onions in a different way: the positioning of the shades causes the viewer's eye to move between the darker outer area on the right of the picture to the lightness of the onion bulbs on the left.

Palette

Lemon yellow
Cypress green
Blue ash
Raw umber

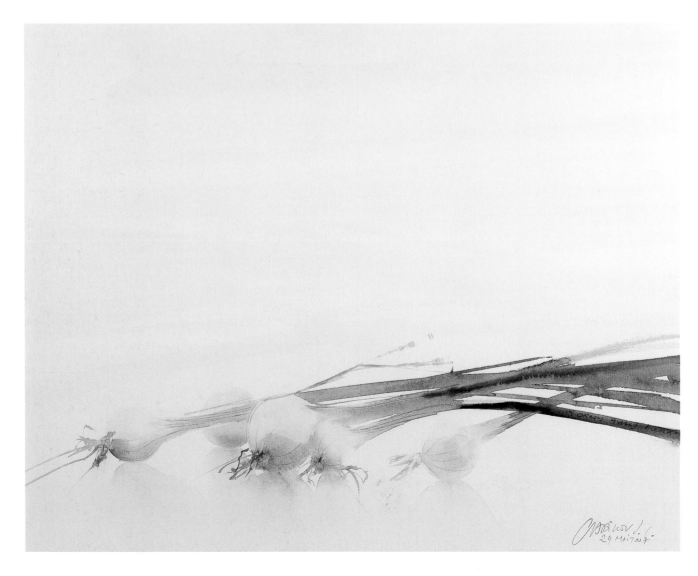

Materials

Paper 65 x 50cm (approx.20 x 26in) stretched over board:
Arches Lavis Fidélis 220g/m² (140lb)
Hogs hair brush for mixing colours on the palette
Squirrel hair wash brushes no.10, no.7, no.3 and no.2-0
Riggers of different sizes
No.12 flat synthetic Kaërell brush
Atomizer
Small round piece of plastic
Fine-tooth comb
Small flat piece of cardboard
Absorbant kitchen paper
Sponges

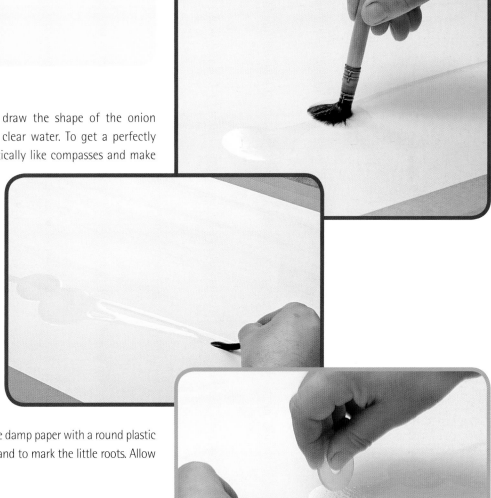

●●● 1 Using the no.7 brush draw the shape of the onion (scallion) bulb on the far left in clear water. To get a perfectly round shape, hold the brush vertically like compasses and make a complete circle, pressing the hairs down. Next draw the stem using a rigger. Draw the other four onions (scallions) in the same way with clear water, finishing with the one on the far right. Tilt the board to distribute the water well throughout the lines you've drawn and absorb the excess.

●●● 2 Make indentations in the damp paper with a round plastic disc to draw the bulb's 'meridians' and to mark the little roots. Allow the water to run into these lines.

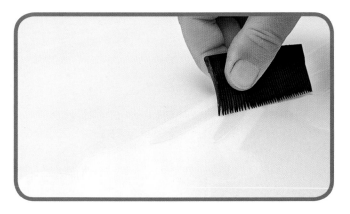

●●● 3 Continue to work with clear water, tracing lines in the stems using a fine-tooth comb.

●●● **4** Mix some blue ash and raw umber on your palette to make a grey-brown. Soak the no.7 brush in this colour and lay it on the lower part of the first bulb. Tilt the board to gently spread the colour to the sides. Absorb the excess at the bottom with a clean, squeezed out paintbrush, leaving only a very light grey. Brush the top of the bulb with a clean, squeezed out brush to remove the pigments and create a passage of light with the background. Paint the bulbs of the three central onions (scallions) in the same way.

●●● **5** To represent the reflection of the bulbs, use a no.10 brush to lay clear water on the area in question, then tilt your board and release the grey of the bulbs so it spreads downwards.

●●● **6** Add volume to the bulbs in the middle. To do this, use a squeezed out no.7 brush to lightly wipe the area at the top, revealing the white of the paper.

●●● **7** Soften the reflections before they dry by misting them with the atomizer. Tilt the board towards you so the excess water and colour runs towards the bottom of the paper. Absorb it with a clean sponge when it reaches the kraft paper. Paint the onion (scallion) on the far right and its reflection in the same way.

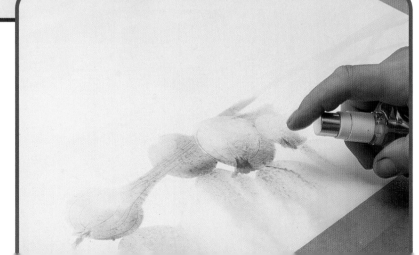

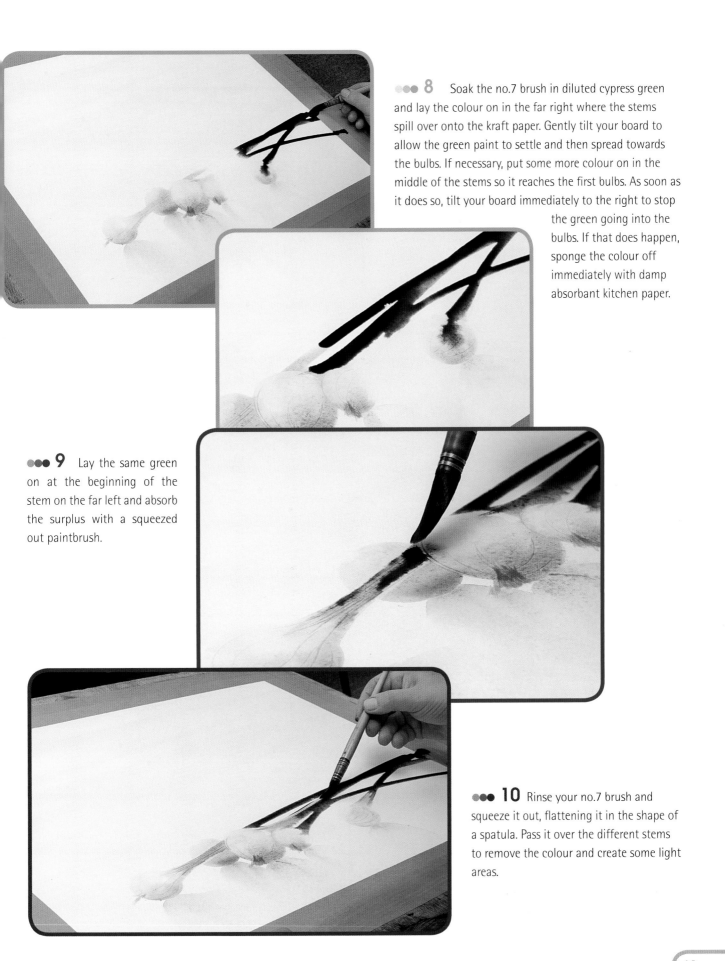

●●● **8** Soak the no.7 brush in diluted cypress green and lay the colour on in the far right where the stems spill over onto the kraft paper. Gently tilt your board to allow the green paint to settle and then spread towards the bulbs. If necessary, put some more colour on in the middle of the stems so it reaches the first bulbs. As soon as it does so, tilt your board immediately to the right to stop the green going into the bulbs. If that does happen, sponge the colour off immediately with damp absorbant kitchen paper.

●●● **9** Lay the same green on at the beginning of the stem on the far left and absorb the surplus with a squeezed out paintbrush.

●●● **10** Rinse your no.7 brush and squeeze it out, flattening it in the shape of a spatula. Pass it over the different stems to remove the colour and create some light areas.

●●● **11** Soak the edge of a piece of cardboard with green and paint the narrowest stems so that they are clearly defined.

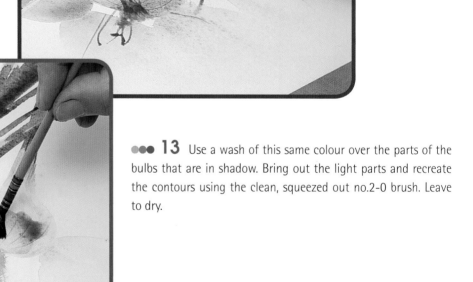

●●● **12** Mix raw umber with yellow and a little cypress green. Lay this colour on the bulbs where the roots grow, using a wash brush. Then with a rigger, paint the little roots from the bulb outwards using short, quick movements.

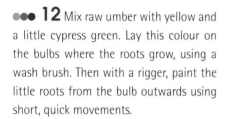

●●● **13** Use a wash of this same colour over the parts of the bulbs that are in shadow. Bring out the light parts and recreate the contours using the clean, squeezed out no.2-0 brush. Leave to dry.

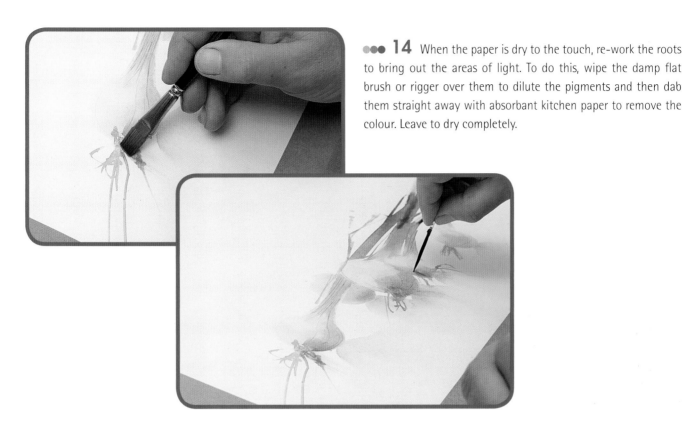

●●● **14** When the paper is dry to the touch, re-work the roots to bring out the areas of light. To do this, wipe the damp flat brush or rigger over them to dilute the pigments and then dab them straight away with absorbant kitchen paper to remove the colour. Leave to dry completely.

●●● Variation

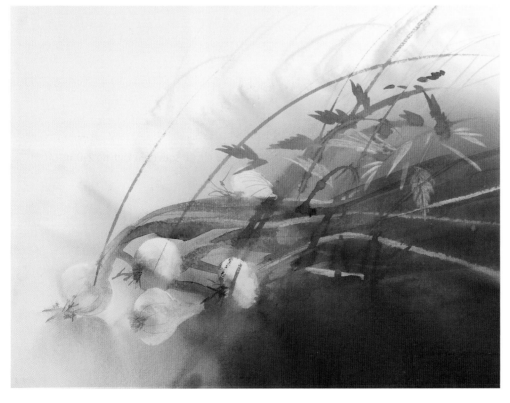

Bunch of spring onions (scallions) in the grass
A corner of the garden in the dampness of the early morning. The ground is soaked by the rain. The viewer's eye explores the secrets hidden between the tufts of dewy grass.

●●● The Seine at Haute-Isle

An enticement to take a trip on the peaceful waters: the eye moves back and forth from the boat in the foreground to the trees in the distance. The shades used are reminiscent of the sepia tones of old photographs and contribute to the air of gentle nostalgia emanating from the painting.

Palette

- Lemon yellow
- Persian red light
- Carmine lake
- Persian violet
- Armor green
- Cypress green
- Blue ash
- Raw umber
- Blue grey

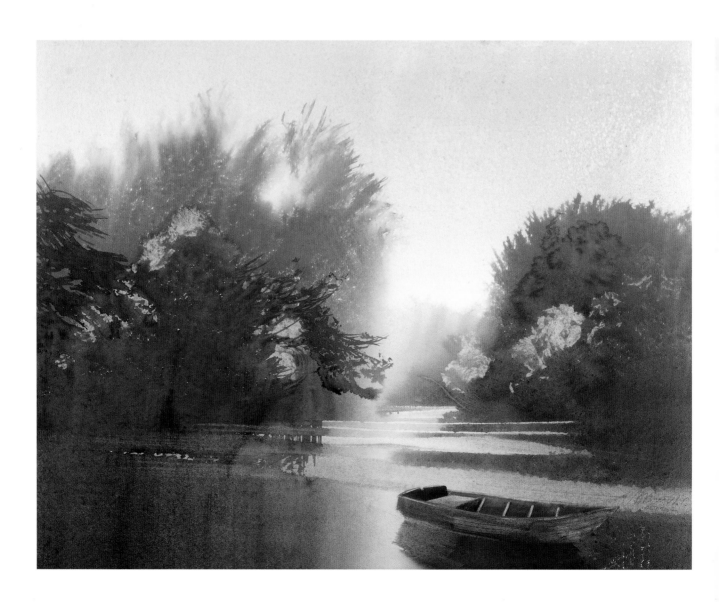

Materials

Paper 65 x 50cm (approx.20 x 26in) stretched over board:
Arches Lavis Fidélis 220g/m² (140lb)
Hogs hair brush for mixing colours on the palette
Squirrel hair wash brushes no.7 and no.3
No.12 flat synthetic Kaërell brush
No.2 fine sable hair brush
Riggers of different sizes
String brush (see p.25)
Atomizer
Piece of flexible plastic (Plexiglass type)
Small flat piece of cardboard
Long thin rigid piece of wood (optional)
Absorbant kitchen paper
Sponges

1 For the very dark green of the trees on the left, mix Armor green with carmine lake and add some raw umber. Soak a sponge with this colour and set it aside on your palette.

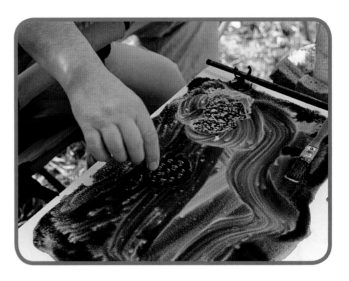

2 For the river and the trees on the right, add some raw umber and some cypress green to the rest of the dark green. Soak a second sponge with this colour and put on one side.

3 Lighten the leftover colour remaining on your palette with lemon yellow and add a little raw umber to obtain the colour of the lighter trees. Soak a third sponge with this colour and set aside.

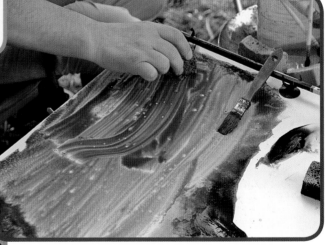

4 For the trees in the distance, add some blue grey to the rest of the previous mix, then a little raw umber and some cypress green. Soak a fourth sponge with this colour and put aside.

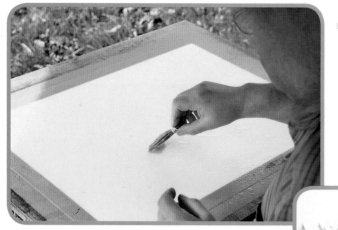

5 Using the atomizer, wet the paper in the area where the trees and the river will be. Keep the sky area clear. Using the no.7 brush, draw the shape of the river with clear water. Then with the string brush indicate the vertical reflections of the river and the branches of the trees using rapid strokes. Put in the details of the leaves with the rigger. Spray the area you're working on regularly with water.

6 Lay the colour in the first sponge on the trees on the left. Tilt your board so that the colour circulates and spreads into the lines you've drawn with water. Draw some finer branches with the string brush. Then lay the mix in the fourth sponge in the area of the more bluish trees in the distance. Continue to add colour, laying the first shade on the trees on the left.

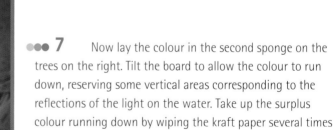

7 Now lay the colour in the second sponge on the trees on the right. Tilt the board to allow the colour to run down, reserving some vertical areas corresponding to the reflections of the light on the water. Take up the surplus colour running down by wiping the kraft paper several times with a clean sponge.

●●○ **8** Run the string brush horizontally across from left to right to draw along the excess colour and take it into the spaces that are still white beneath the trees on the left. Again lay the colour in the second sponge on the right for the reflection of the trees in the water.

●●○ **9** Hold your board vertically. Using the atomizer, separate the pigments to reveal patches of light on the river. Absorb the excess water on the kraft paper at the bottom with a sponge, to prevent it peeling off.

●●○ **10** Cover the edge of a piece of plastic with absorbant kitchen paper and remove the colour on the reflections in the river. Repeat the exercise, changing the paper regularly.

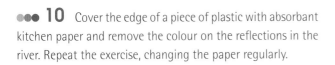

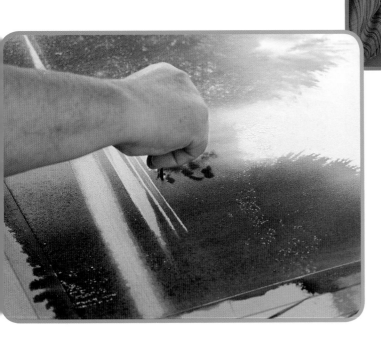

●●○ **11** Load a rigger with colour from the second sponge and paint the dark areas of the clumps of trees on the right and the dark reflections in the river.

12 Then lay the colour from the third sponge onto the light areas of the trees on the left and the right. Tilt your board so the colour runs down and creates the reflection of the trees in the water. Take up the excess colour as necessary with the no.7 brush, having first squeezed it out.

13 Run the string brush downwards over the river to draw down the colour that's still damp and convey the vertical reflections. You can hold a long, rigid stick in the other hand, away from the paper as a kind of marking gauge, to give you a firm, precise movement.

14 Make some compact balls of absorbant kitchen paper. Roll them in the still-damp colour to create texture on the leaves. Squeeze out the no.3 brush and use it to refine the highlights.

15 Load the string brush with colour from the first sponge. Tap it on the paper to suggest the darker branches of the foliage. Leave to dry completely and leave the palette and sponges as they are.

●●● **16** Put the rest of the colour from the first sponge onto the palette and add a little cypress green to it. With the no.3 brush and some clear water, draw the shape of the boat and its reflection in the river. Absorb the excess water. Then use the no.7 brush to lay the colour in the top part of the boat. Tilt your board to distribute the colour and allow it to drain away, and at the same time draw in the outlines with the fine sable brush. Absorb the excess on the kraft paper with a clean sponge.

●●● **17** Cover the edge of a piece of flexible plastic with absorbent kitchen paper to lift off the colour from the edges of the boat and the area where it makes contact with the water of the river. Then with a small piece of flat cardboard covered in absorbent kitchen paper, do the same with the seat and the wood of the boat's frame.

●●● **18** To highlight the dark areas in the boat, bring out the light areas by lightly brushing the paper with the flat, damp brush to dilute the pigments, then dab them with absorbent kitchen paper to take off the colour. Continue to refine the details, each time allowing drying time. Then leave the whole thing to dry completely. Wash your palette and materials while you're waiting.

●●● 19 Laying on a glaze will give a haziness to the distance. Mix some blue ash, raw umber and lemon yellow to make a warm grey. Soak a sponge with this colour and put it to one side on your palette. Moisten the whole paper with the atomizer, starting with the sky. Make the excess run out to the edges by tilting the board, and absorb it with a clean sponge. Lay on the coloured glaze in the top right and tilt the board to spread it over the whole sky. Then hold the board vertically so the colour runs down the trees and again from left to right to send it back up towards the tops of the trees and create the hazy effect. Wipe the kraft paper regularly to absorb the excess colour. When you've finished the glaze, allow the paper to dry completely. In the meantime, clean your palette and equipment.

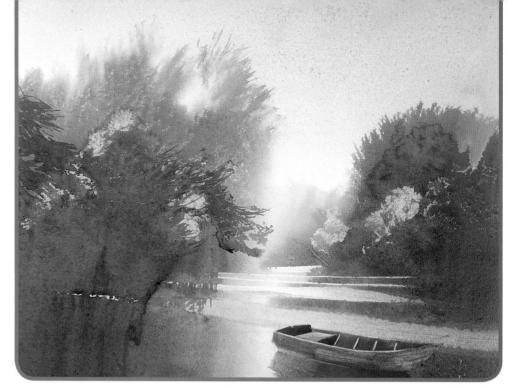

●●● 20 Mix together some Persian red light and some Persian violet. With the fine sable brush, highlight the edges of the boat with a thin red line. You can use a long rigid stick, held in your other hand away from the paper, to give you a firm and accurate stroke.

●●● 21 To finish, rework the left part of the composition, defining the clumps of trees at the water's edge and highlighting their vertical reflections in the water. Dampen this area with the atomizer, then rub the edge of a piece of flexible plastic covered in absorbant kitchen paper from the bottom of the trees to the bottom. Change the absorbant kitchen paper and repeat the operation.

●●● Variations

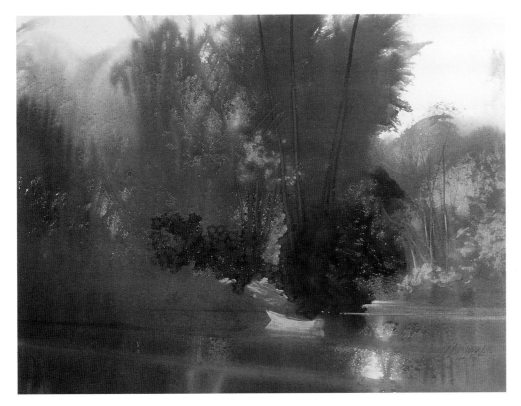

Entrance to the tranquil branch of the river at Haute-Isle
This peaceful branch of the Seine at Vétheuil is not often visited. The unspoilt islands are filled with birds of all kinds. The little boat adds an air of mystery as it floats in the shadow of the bank.

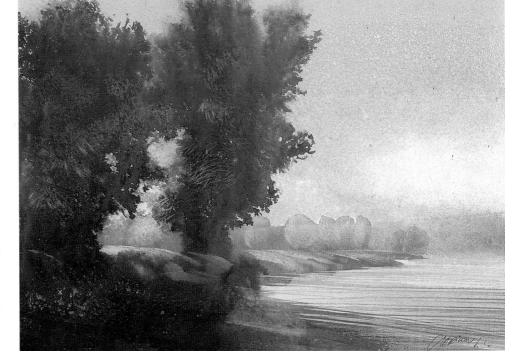

A grey day on the Seine
Some days appear to be colourless, when actually the colours are there but are very subtle. Between the two large trees on the left, a background lit by pure yellows encourages the viewer's imagination to wander in peace and quiet.

●●● Mussels and prawns (shrimps)

A composition structured around the visual contrast between 'open' and 'closed'. The values of the shells are represented in such a way that the middle one is the least dark, which in turn, attracts the eye with its rainbow-coloured reflections.

Palette
- Lemon yellow
- Persian red light
- Ruby red deep
- Armor green
- Cerulean blue
- Ultramarine blue deep
- Raw umber

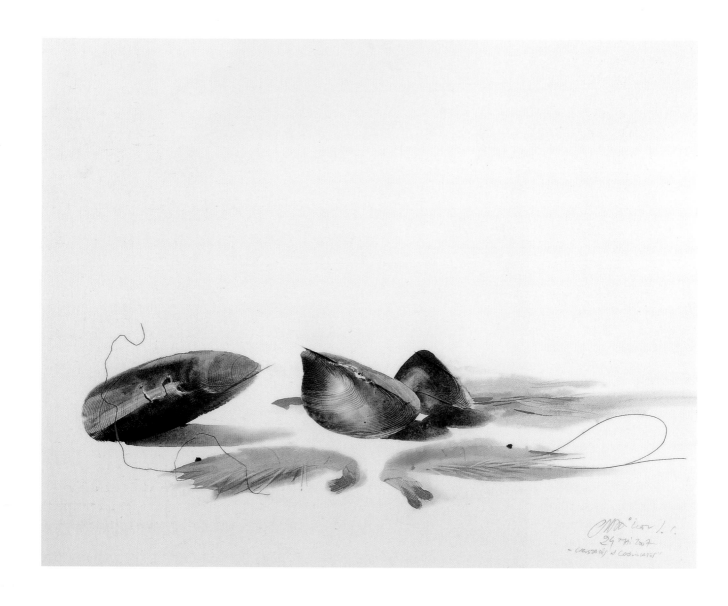

Materials

Paper 65 x 50cm (approx.20 x 26in) stretched over board:
Arches Lavis Fidélis 220g/m² (140lb)
Hogs hair brush for mixing colours on the palette
Squirrel hair wash brushes no.7 and no.2-0
No.2 fine sable hair brush
No.12 flat synthetic Kaërell brush
Atomizer
Paraffin wax disc
Fine-tooth comb
Wooden skewer
Drawing pen
Small flat piece of cardboard
Small round piece of plastic
Absorbant kitchen paper
Sponges

●●● **1** Draw the shape of the first mussel in clear water using a no.7 brush. Absorb the excess water. Draw in the highlighted part of the shell with a small sharpened piece of paraffin wax. Continue working with clear water, drawing the fine-tooth comb in a single movement following the oval line of the shell, to mark its striations in the paper. Lay on a little diluted Armor green in the illuminated area and absorb the excess with the brush.

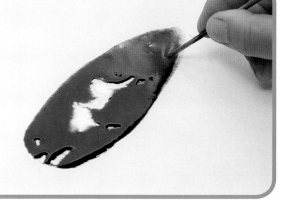

●●● **2** Lay a mix of raw umber, Armor green and ultramarine blue deep on the edges of the shell. Tilt the board so that the colour spreads towards the centre. Then put a mix of raw umber, lemon yellow and Persian red light on the right side of the shell. Mark a few small details in the paper with a small wooden skewer. The pigments will run into them.

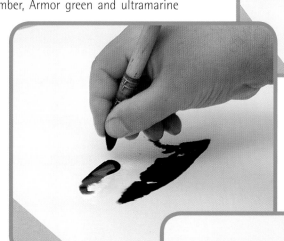

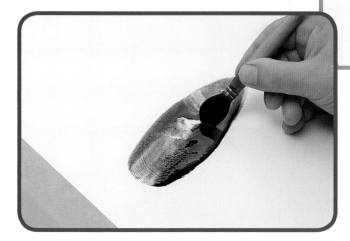

●●● **3** With a squeezed out no.7 brush flattened in the shape of a spatula, lift out some colour to create light areas. Pass the comb over to striate the right side of the shell and continue to work on the highlights.

4 With a brush pass some clear water over the shadow cast by the mussel and allow the colour in the lower part of the shell to spread into it. Take up the no.7 brush again and introduce some highlights at the top edge of the shell. Then accentuate the fine lines of the texture around the paraffin wax with the fine sable brush, adding some shadows. Leave to dry.

5 With the no.7 brush lay some Persian red light, and then a mix of Armor green and yellow, on the part of the shell that catches the light. Absorb the excess with a clean brush.

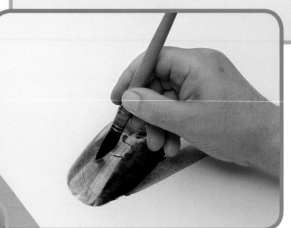

6 Draw the shape of the second mussel with clear water using the no.7 brush. Absorb the excess water. With the no.2-0 brush, paint the rainbow-coloured reflection in the middle by putting Persian red light and Armor green side by side. Tilt your board so that the colour runs downwards. Mark the striations of the shell with the fine-tooth comb.

7 Mix together some ultramarine blue deep, Armor green and raw umber. Apply this colour to the lower part of the shell with the brush. Tilt your board down and to the left and absorb the excess liquid. Rub with paraffin wax to highlight the areas of lime deposit on the shell.

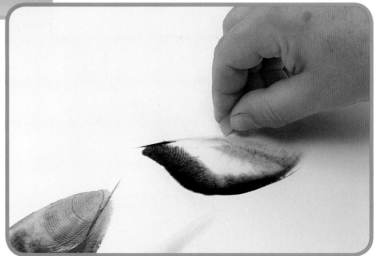

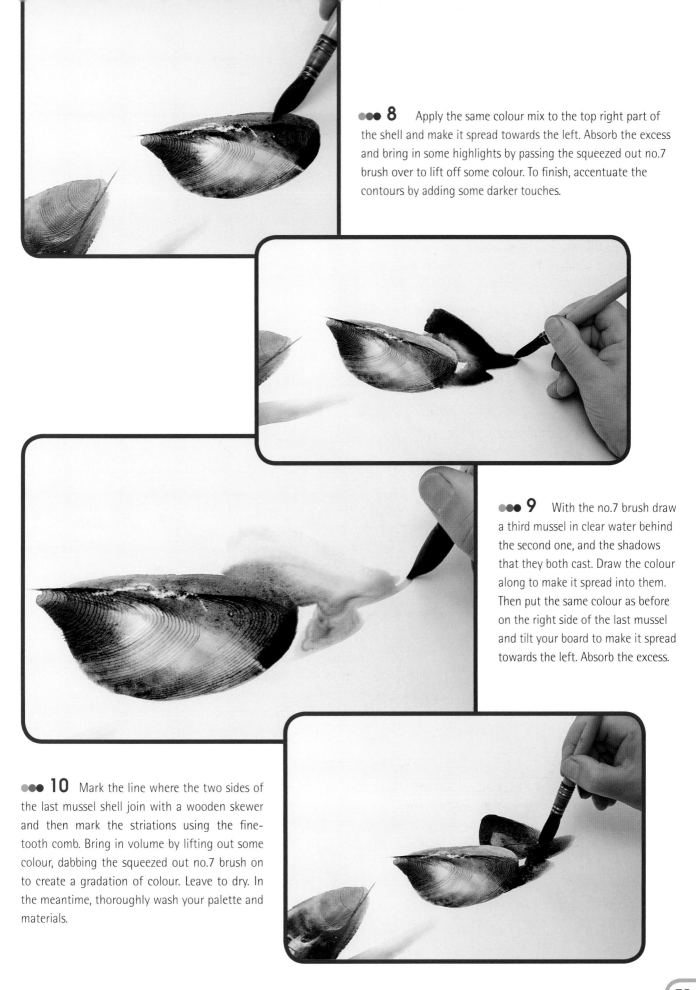

●●● **8** Apply the same colour mix to the top right part of the shell and make it spread towards the left. Absorb the excess and bring in some highlights by passing the squeezed out no.7 brush over to lift off some colour. To finish, accentuate the contours by adding some darker touches.

●●● **9** With the no.7 brush draw a third mussel in clear water behind the second one, and the shadows that they both cast. Draw the colour along to make it spread into them. Then put the same colour as before on the right side of the last mussel and tilt your board to make it spread towards the left. Absorb the excess.

●●● **10** Mark the line where the two sides of the last mussel shell join with a wooden skewer and then mark the striations using the fine-tooth comb. Bring in volume by lifting out some colour, dabbing the squeezed out no.7 brush on to create a gradation of colour. Leave to dry. In the meantime, thoroughly wash your palette and materials.

●●● **11** Dilute some Persian red light on one side of your palette and some ruby red deep on the other. Allow the colours to mix without interfering. With the brush you use for wetting the paper, draw the shape of a prawn (shrimp) in the foreground with clear water. Rework the outline for the curved part of the tail and the more pointed parts of the head with a fine brush. Spread the water, tilting your board and absorbing the excess as necessary. Fill the drawing pen with Persian red light and draw the antennae with a steady hand, going from the dry paper towards the damp body of the prawn (shrimp).

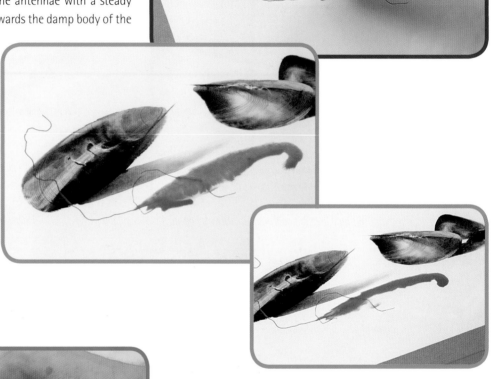

●●● **12** Apply some Persian red light to the prawn's (shrimp's) head and tilt your board to spread the colour towards the right, all the way to the end of the tail and then towards the ventral area.

●●● **13** Draw the legs with the edge of a small piece of flat cardboard, pulling the colour towards the dry area. Absorb the excess colour using the squeezed out and flattened no.7 brush, then lift out some colour to create areas of light.

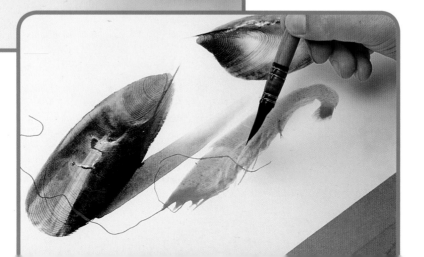

●●● **14** Press down on the paper with a small piece of round plastic where the legs are so that the pigment settles there. Do the same with a fine-tooth comb at the end of the tail.

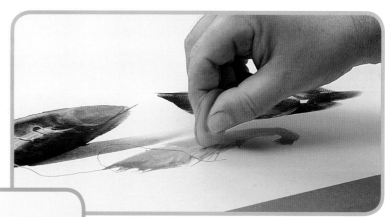

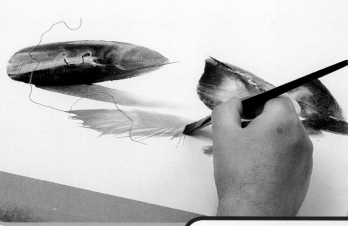

●●● **15** Apply some dark red at the top of the head and the end of the tail with the brush. Absorb the excess colour. Leave to dry. Continue to 'sculpt' the light areas, brushing the paper lightly with the flat, damp brush to soften the pigments and dabbing with absorbent kitchen paper as you go along to lift out the colour.

●●● **16** Moisten the ventral area of the prawn (shrimp) and lay on a light mix of cerulean blue and raw umber to which you've added a little ruby red deep. Then squeeze out your no.7 brush and brush it over the colour you've just laid on, following the slope of the legs. Use the same mix for the shadow cast by the tail. Allow to dry. When it is dry, rework the feet, 'sculpting' the light areas with the flat damp brush and some absorbent kitchen paper, as in step 15. To finish, mark the eye with a little raw umber mixed with dark red and cerulean blue.

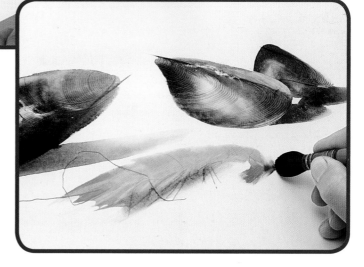

●●● 17 Draw a second prawn (shrimp) with clear water. Fill your drawing pen with a mixture of the two reds and draw the antennae in a smooth movement. Then, as before, lay a mix of Persian red light and ruby red deep in the top part of the prawn (shrimp) with the no.7 brush. Tilt your board so that the colour spreads through the whole body. Absorb the excess colour to lighten the hue.

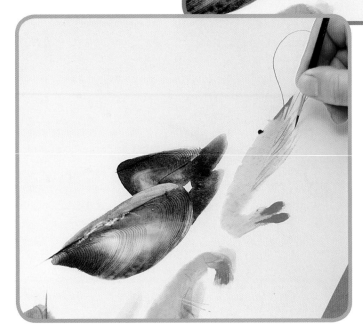

●●● 18 Mark the end of the tail with the fine-tooth comb. Draw the legs with the edge of a small piece of cardboard, pulling the colour towards the dry area. Put some dark red at the ends of the tail and the head. Using the fine sable brush, mark the eye with the same mix as at step 16. Then highlight the legs and mark the hollows in the shell with dark red.

●●● 19 Paint the shadow cast, proceeding as at step 16. Lighten it by passing the clean, squeezed out no.7 brush over it. Leave to dry. Bring back some white areas by lightly brushing the paper with the flat, damp brush and dabbing it with absorbant kitchen paper. To finish, wet the top of the shell with the brush. Absorb the excess water and put on some Persian red light. Leave to dry.

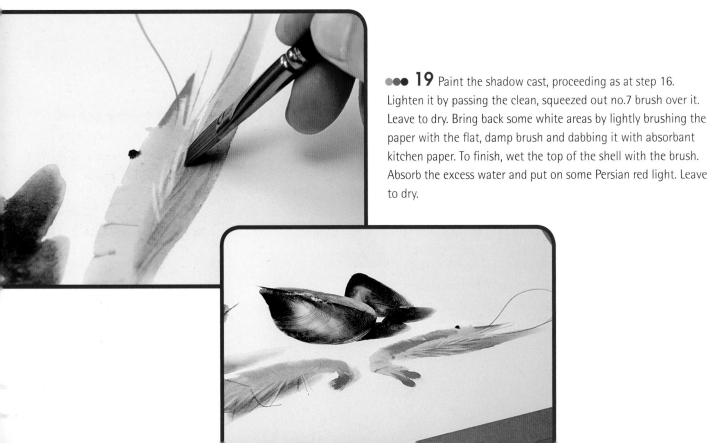

●●● **20** Rub some paraffin wax to the right of the two mussels and give the suggestion of a third prawn (shrimp) in transparent colour to balance the composition. Similarly, add a touch of red on the left of the central mussel. To finish, draw in some darker red lines with the edge of a small piece of flat cardboard. Leave to dry completely before removing the paraffin wax using a hairdryer and some absorbant kitchen paper.

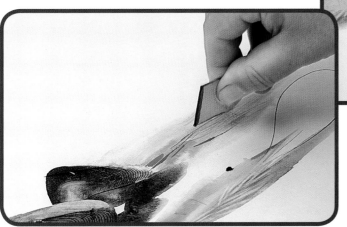

●●● Variation

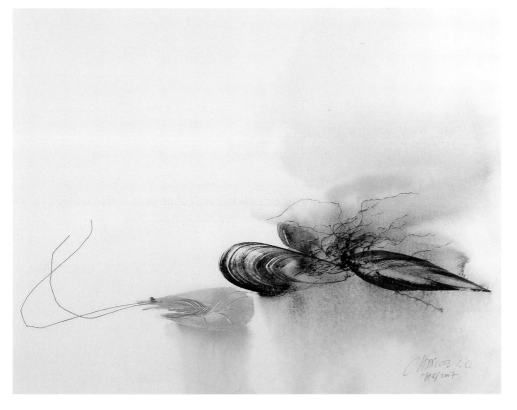

Prawn (shrimp) and two mussels
They were left over on a market stall. The dynamic of the two groupings provides contrast and is tempered by the addition of the chaos created by the seaweed between the two mussels. This new centre of interest distracts from the splash of red from the prawn (shrimp).

●●● The bramble bush

A composition that plays with different contrasts: graphic contrasts (stripes, streaks and flat tints), contrasts of rendering (from soft and hazy to clear and sharp), of shade (cool light reds to warm dark reds), of value (from bright reds to ochres and oranges to greens) and of complementary elements.

Palette
- Lemon yellow
- True carmine red
- Ruby red deep
- Cypress green
- Cobalt blue
- Raw sienna
- Blue grey

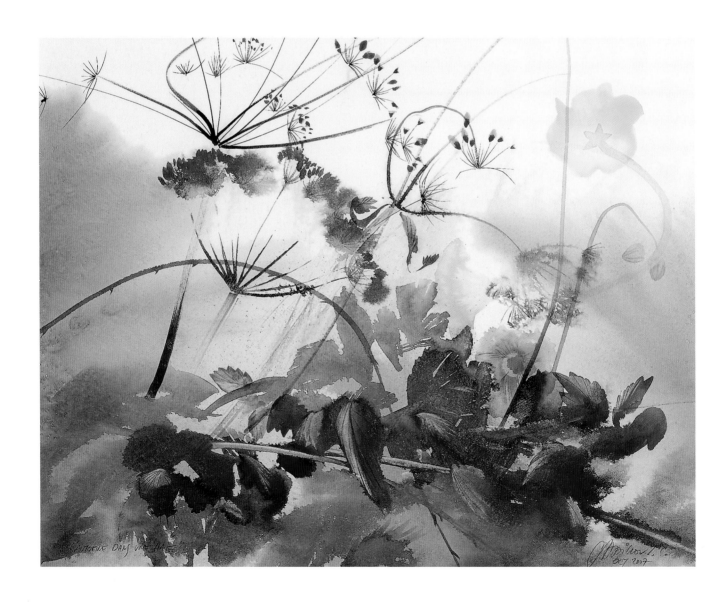

Materials

Paper 65 x 50cm (approx.20 x 26in) stretched over board:
Arches Lavis Fidélis 220g/m² (140lb)
Hogs hair brush for mixing colours on the palette
Squirrel hair wash brushes no.7, no.3 and no.2-0
No.2 fine sable hair brush
Riggers of different sizes
No.12 flat synthetic Kaërell brush
No.40 synthetic spalter brush
Drawing pen
Atomizer
Small piece of round plastic
Small fine-tooth comb
Small plastic tube
Piece of flat cardboard
Small thin piece of wood
Absorbant kitchen paper
Sponges

Preparation

Soak the small piece of wood in water. Poplar wood is ideal because it doesn't contain any resin. It's very supple, it swells rapidly and it has good capillary action.

●●● **1** Prepare a dark green on your palette, by mixing a good amount of cypress green with some sienna, then add a little cobalt blue. Wet the edge of a rectangular piece of flat cardboard to aid capillary action, then squeeze the water out of it with absorbant kitchen paper. Soak it with the dark green and dab the colour on the paper to paint the fan of stems of the umbellifer almost in the centre of the composition. Press gently on the card to create lines that are narrower towards the ends.

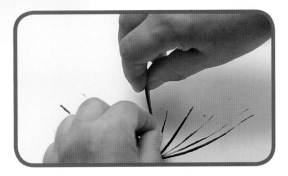

●●● **2** Moisten the area where the flowers will be with the atomizer before drawing them in with the drawing pen filled with dark green. Add some sienna to the green and paint the flowers in the moistened area with a fine wash brush. Moisten the paper with the atomizer from time to time as necessary.

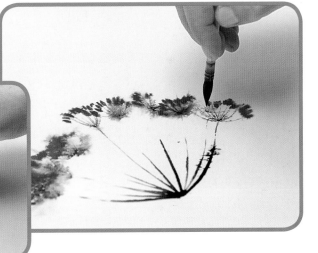

●●● **3** Take the small piece of wood you've soaked and squeeze the water out of it with absorbant kitchen paper. Soak it in the same dark green to draw the stem, from the top down to the bottom. Draw the main stem of another umbellifer on the right of the first one in the same way, and then its three secondary stems.

4 Moisten the area where the flowers on the right will go with the atomizer, then draw in the fan-shaped stems with a fine rigger loaded with green. Using the fine sable brush paint the tiny flowers as little dots side by side, in a mix of blue grey and cobalt blue. Join the little bunches of bluish flowers to their stems with dark green lines created with the drawing pen. Then paint the dark green leaves at the top of the stem with a fine wash brush. Mark the veins in the moist paint by pressing on the paper with the plastic disc so that the pigments run into them.

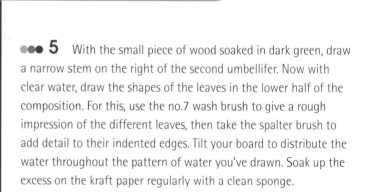

5 With the small piece of wood soaked in dark green, draw a narrow stem on the right of the second umbellifer. Now with clear water, draw the shapes of the leaves in the lower half of the composition. For this, use the no.7 wash brush to give a rough impression of the different leaves, then take the spalter brush to add detail to their indented edges. Tilt your board to distribute the water throughout the pattern of water you've drawn. Soak up the excess on the kraft paper regularly with a clean sponge.

6 Soak a sponge in the same dark green. Deposit the colour in the central part of the foliage you've drawn in water. Experiment with the tilt of your board to make the wash spread into the design drawn in water. Apply some colour in the left part of the composition and continue in this way until you've filled the whole design. Regularly absorb the excess water, wiping the kraft paper at the bottom of the paper with a clean sponge.

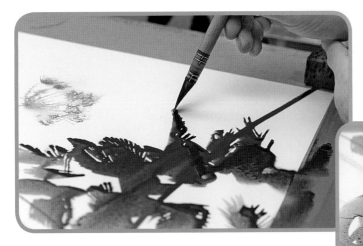

●●● **7** As the light comes from the left, tilt your board more to the right to take the wash in that direction and create gradations of green in the leaves. Absorb the excess on the right with a clean squeezed out no.7 brush.

●●● **8** Then spray all the leaves straight away to soften the sharpness of their outlines and prevent dark edges from forming. Absorb the excess water again with the brush, working meticulously leaf by leaf. Only a few fibres from the brush must touch the paper. The spray keeps the paper humid and the texture that is created between the leaves and the paper gives the tangled impression of the plants.

●●● **9** Clean your palette roughly with a sponge and dilute some ruby red deep on it. Start painting the red leaves of the brambles on the left and in the middle with a no.3 wash brush. Gradually add some sienna and paint the leaves further to the right. Then draw the long horizontal drooping stems using a rigger. Paint the thorns with the fine sable brush on the dry paper.

10 Mark the fine veins of the bramble leaves on the paper with a small piece of round plastic. Squeeze out the no.7 brush and flatten it in a spatula shape. Pass it over the parts of the leaves that are exposed to the light to lift out some colour and create highlights.

11 With the sharp edge of a small plastic tube, mark the main veins of the leaves on the paper. Continue to work the highlights on the leaves and move on to the stems. Leave to dry. Meanwhile, clean your equipment.

12 Put some carmine red and cypress green on your palette. Draw the shape of the hollyhock on the top right with the no.3 wash brush and clear water. Take up the excess water with the brush. Put some very diluted red at the top of the flower and tilt the board to distribute the colour, taking care to leave a white unpainted area in the centre. Absorb the excess colour until you're left with a very pale pink. Paint the furthermost hollyhock on the left in the same way and take up the excess colour with absorbant kitchen paper which you've twisted to avoid spreading the pink into the green of the leaves.

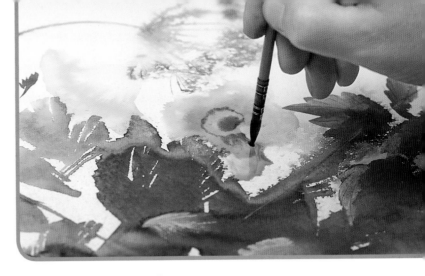

●●● **13** Following the same procedure, paint the last hollyhock with a stronger shade in the centre. Lighten the outside edges of the petals by passing a clean, squeezed out wash brush over them to lift out the colour. For the centre, lay on some cypress green mixed with a little sienna, using the fine wash brush. Put in the last highlights, absorbing the colour with the no.7 wash brush, clean and squeezed out. Then mark the veins of the petals on the paper using the round piece of plastic. Twist a piece of absorbant kitchen paper and take up the colour to create some lighter areas. To finish, again put a little green-brown mix in the centre of the flower. Leave to dry thoroughly.

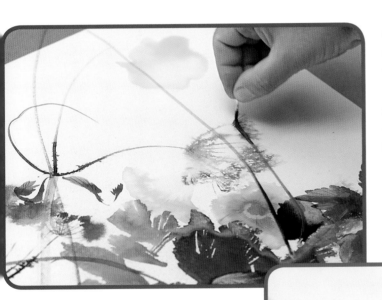

●●● **14** Paint a leaf so that it hangs over the last hollyhock. Begin by drawing it with clear water and then, with a wash brush, lay on some cypress green mixed with a little sienna. Tilt your board to distribute the glaze. Absorb some colour with a clean sponge to lighten the right part of the leaf. Then add some blue grey to the cypress green, soak the edge of a rectangle of flat cardboard with this mix and paint the beginning of the large stem going over the hollyhock. Using a rigger, follow the line of this stem to the top of the leaf and draw another one falling away to the right.

●●● **15** Add some blue grey to the previous mix to represent the buds falling off of the plant. Put the colour on with a wash brush, pressing down on the fibres to create the shape of the buds. With the dry drawing pen, mark the veins of the buds on the paper. Absorb the excess colour using the squeezed out brush. To finish, pass the squeezed out brush over the colour here and there to create highlights and introduce volume.

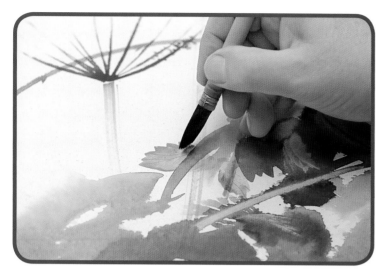

●●● **16** Paint the small bramble leaves most exposed to the light in orange (a mix of carmine red and yellow) using a no.3 brush. Absorb the excess colour, then darken the edges of the leaves with a more concentrated colour. Mark the veins while the colour is still wet by pressing on the paper with a plastic disc. Finish by passing the clean, squeezed out brush over it to create some highlights.

●●● **17** Mix the remaining colours on your palette (green, orange and red) to obtain a warm brown. Wedge a small piece of fine-tooth comb against a piece of flat cardboard and soak the cardboard with the brown. Paint the stem of the large umbellifer in one single stroke. Use a rigger to paint the stalks branching off the stem. Then draw the flowers with the drawing pen but don't necessarily join them to the stalks, to add lightness to the upper part of the composition. To finish, paint the small flowers with a fine wash brush, adding a little yellow to the brown.

●●● **18** Now paint the stem of the hollyhock over on the right with a light green. Leave the whole thing to dry thoroughly. In the meantime, clean your palette.

19 In order to recreate the cool atmosphere of a neglected garden, finish your composition by laying on a pale green glaze in three steps. Prepare a generous quantity of a very diluted mix of blue grey and cypress green. Soak a sponge with this colour and set it to one side. Moisten the painting with the atomizer and absorb the excess water with a clean sponge on the kraft paper. Lay the colour on first in the bottom left, then tilt the board to spread it upwards. Once you've laid on the colour and absorbed the excess wash, repeat, laying the colour on from the centre bottom and then the bottom right.

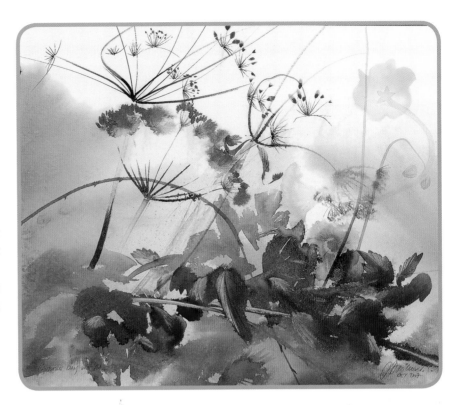

●●● Variation

The insect and the thistles
Inhabited as they are by a whole population of insects, hedges are an inexhaustible source of inspiration for me. When flowers peep through the branches there may be an opportunity to paint a bee, come to gather pollen.

●●● The avenue of Douglas firs

A row of large trees inevitably has an air of dominance about it. But you can guide the viewer's eye, taking it away from the narrative to appreciate it pictorially. The background of the painting is deliberately impenetrable, but the light filtering in through the leaves provides a welcome distraction to the eye.

Palette
- Lemon yellow
- Persian red light
- Carmine lake
- Persian violet
- Armor green
- Cypress green
- Cobalt blue
- Ultramarine blue deep
- Raw umber

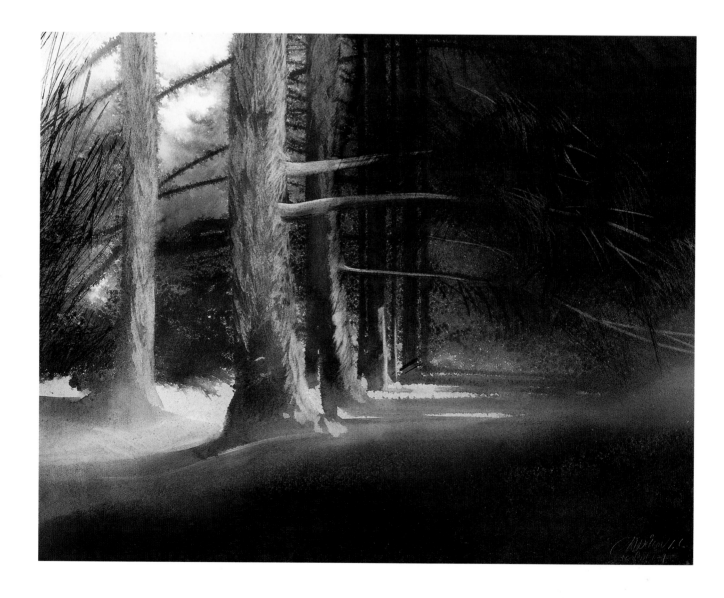

Materials

Paper 65 x 50cm (approx.20 x 26in) stretched over board:
Arches Lavis Fidélis 220g/m² (140lb)
Hogs hair brush for mixing colours on the palette
Squirrel hair wash brushes no.7, no.3 and no.2-0
Riggers of different sizes
No.12 flat synthetic Kaërell brush
String brush (see p.24)
Atomizer
Long rigid stick
Absorbant kitchen paper
Sponges

●●● **1** Dilute a good quantity of Persian violet on your palette. Add some ultramarine deep to it and then some raw umber, to obtain a muddy purplish colour. To finish, add some cypress green. Soak a sponge with this colour and put it to one side on the palette. Keep the rest of the colour on your palette for use later.

●●● **2** Draw the mass of foliage with generous amounts of water from the atomizer. With the no.7 wash brush and some clear water, start drawing the vertical trunks of the largest trees and the contours of the ground. Continue drawing the trunks, moving progressively towards the narrowest ones in the background. Change the size of your wash brushes as you go. Finish with a rigger. You can use a long stick, holding it in the other hand like a marking gauge, off the paper, for a firm, precise, vertical movement.

●●● **3** Apply some more clear water to the trunks with a clean wash brush. Continue by drawing the horizontal or drooping branches with riggers of different sizes. Spray water around the branches. Then add water at the bottom of the trunks and on the contours of the ground and draw the shadows of the trees with a fine rigger. For the narrower branches on the right side of the painting, spray with water and draw them with the fine rigger in light, feathery movements. These droplets of water, applied in this way, will give the contours of the branches the prickly appearance of conifers.

●●● **4** Tilt your board to get rid of the excess water at the top of the trunks and absorb it with a sponge on the kraft paper. Finish the water drawing by representing the small leaves falling on the left and right with the string brush.

5 Apply colour from the sponge you prepared at step 1 to the base of the large trunks. Tilt your board to allow the paint to spread into the branches, invading the pattern you've drawn in water. Proceed in several steps, regularly sponging up the excess colour on the kraft paper.

6 Add cypress green to some of the purple-brown remaining on your palette and soak a second sponge in the resulting colour. Reserve some purple-brown for the next step. Lay on the colour in several places in the foliage on the right and the undergrowth on the left. Tilt the board to make it run through the whole of the pattern.

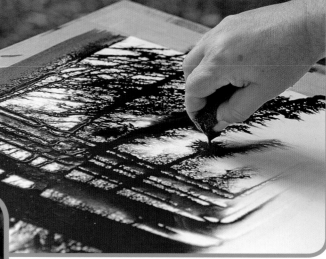

7 Now make the colour for the glaze to go on the ground at step 8 by adding some lemon yellow to the rest of the purple-brown. Soak a sponge with this colour and put it to one side on your palette. Leave some colour on your palette deliberately. It will be useful for the mix at step 11. Moisten the ground area with the no.7 brush and experiment with the tilt of the board, allowing the colour of the trees to spread downwards, then to the left. Highlight areas of the ground by lightly brushing the paper with a squeezed out brush to lift out any colour that may have dropped onto them. Drain off the excess colour to the sides and absorb it with a sponge.

●●● **8** Continue working on the ground area wet-on-wet, laying the colour from the sponge over on the right. Tilt the board to the left and then down and to the right to distribute the colour. To finish, hold the board vertically, tilt it to the left and catch the excess colour with the sponge.

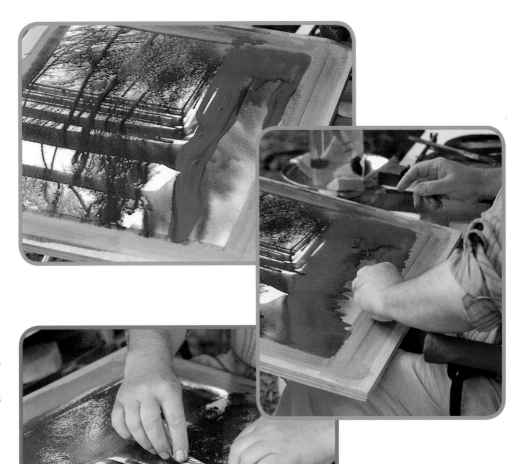

●●● **9** Twist some sheets of absorbant kitchen paper and apply them to the light areas of the trunks in the foreground to lift out some colour.

●●● **10** Continue by lifting out colour from the horizontal branches using the no.7 brush squeezed out. Go from the bottom of the branch to the tip in one single movement. As the first step of the wet-on-wet work is finished, leave the paper to dry completely. Do not rinse your palette.

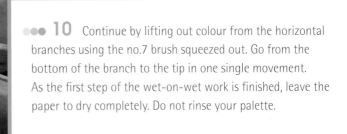

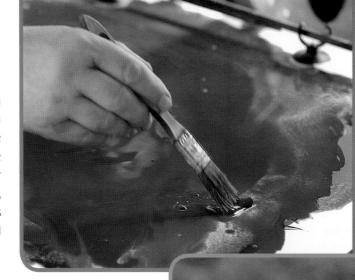

●●● **11** You're now going to work the contrasts with a dry brush. Moisten the colour left on your palette at step 7 and add Armor green, ultramarine blue deep, carmine lake and cypress green to obtain a grey tinged with green-brown.

●●● **12** Use the atomizer to moisten all the branches on the right side of the composition. Load the string brush with the mix you've just prepared, then brush it across the paper in criss-cross movements to represent the spiny appearance of the foliage. Leave some areas of light.

●●● **13** Tilt the board to the right, holding it vertically. Spray on some water to soften the colour of the ground at the bottom of the trees. Allow the excess water to drain off and soak it up on the kraft paper at the bottom with a sponge. Dab with absorbant kitchen paper to lighten certain areas. Tilt your board the other way and begin again.

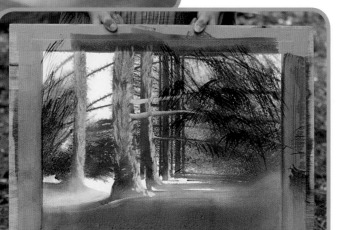

●●● **14** Allow the paper to dry completely before moving on to the glaze. Do not rinse your palette.

●●● **15** Add ultramarine blue deep and Persian violet to the colour remaining on your palette to obtain an almost bluish black. Spray the entire composition, keeping some tiny dry areas between the droplets in the leaves. Soak up the excess water on the kraft paper with absorbant kitchen paper.

●●● **16** Apply the colour from the sponge in the top right of the composition. Tilt the board to the left to spread the colour over to the large tree trunks. Then tilt it to the right to redirect the colour. Keep tilting it to the right until it is vertical. Sponge off the excess colour from the kraft paper at the bottom.

●●● **17** Turn the composition the right way up again and spray the tree trunks to push the pigments towards the right, separating the trees from the glaze. Do the same with the area of ground on the right of the avenue. Then separate the ground in the foreground, moistening it thoroughly for the glaze in the next step.

18 Lay the remaining colour from the sponge on the ground area, over on the right. Tilt the board to the left to spread the wash to the light areas in the avenue, then straight away tilt it towards the right to redirect the wash and drain it away. Reveal some lighter areas as necessary, by pushing the pigments back with the atomizer.

19 Squeeze out the no.7 wash brush and pass it over the main branches to highlight them, leaving the end part in shadow.

20 Put some shadows in at the beginning of the branches using the flat brush. Rework the light in the lighter parts of the tree trunks by delicately brushing the colour with the moist brush to dilute the pigments and sponging it off straight away with some absorbent kitchen paper. Follow on with a fine, moist rigger and then with the string brush, continuing to take off the colour with absorbent kitchen paper. Leave to dry completely.

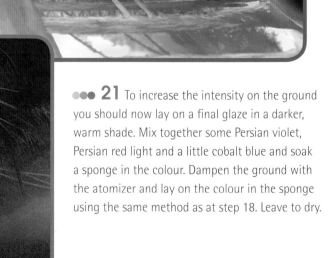

21 To increase the intensity on the ground you should now lay on a final glaze in a darker, warm shade. Mix together some Persian violet, Persian red light and a little cobalt blue and soak a sponge in the colour. Dampen the ground with the atomizer and lay on the colour in the sponge using the same method as at step 18. Leave to dry.

●●● Variations

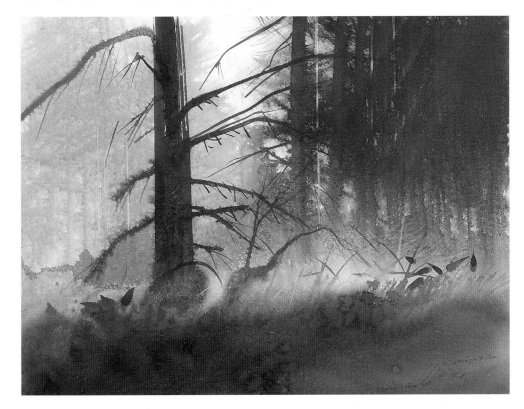

The master tree
In this watercolour I am playing with contrasts of values, shades and techniques with the aim of drawing the viewer into the painting.

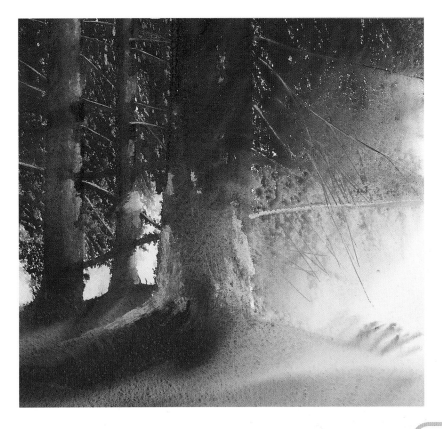

Avenue of Douglas firs no.5
It was stiflingly hot that day. To prevent the water evaporating too quickly on the paper I had to paint in the shade of the trees. In this small watercolour I've tried to convey that scorching sunlight piercing the leaves of the trees.

●●● Pears and a strawberry

How do we deal with the spaces between the fruits?
The weight of the pear on the left could so easily
unbalance the composition but the small splash of
red of the strawberry provides a joyful and deliciously
evocative counterbalance.

Palette

- Lemon yellow
- Persian red light
- Ruby red deep
- Armor green
- Cypress green
- Raw umber
- Blue grey

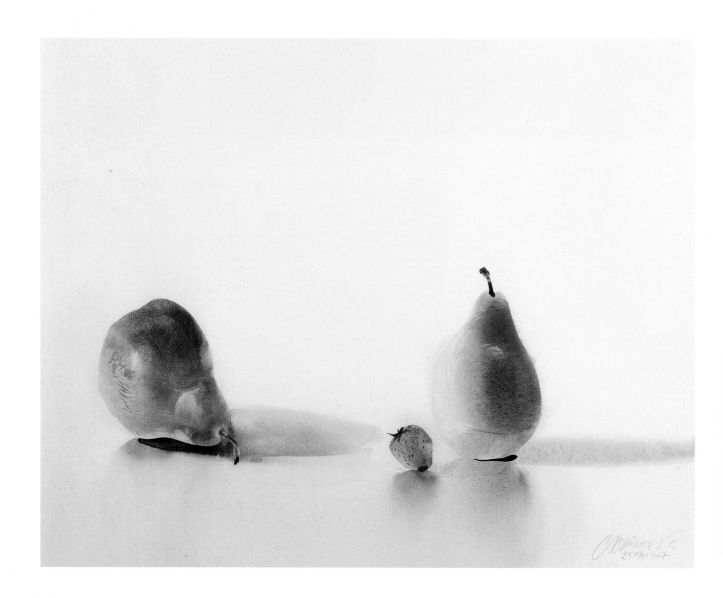

Materials

Paper 65 x 50cm (approx.20 x 26in) stretched over board:
Arches Lavis Fidélis 220g/m² (140lb)
Hogs hair brush for mixing colours on the palette
Squirrel hair wash brushes no.10, no.7, no.3 and no.2-0
No.2 fine sable hair brush
No.12 flat synthetic Kaërell brush
Wooden skewer
Atomizer
Paraffin wax
Small piece of flat cardboard
Absorbant kitchen paper
Sponges

●●● 1 Draw the outline of the strawberry in clear water using the sable hair brush. Continue by drawing criss-crossing lines inside the strawberry as close together as possible. Absorb the excess water using a clean, squeezed out wash brush. With the no.2-0 brush apply some Persian red light in the left part of the strawberry. Tilt the board to make the colour run into the lines of water. Then apply some ruby red deep in the right part of the strawberry.

●●● 2 Draw the shape of the strawberry's reflection with clear water and the no.10 brush. Now tilt the board downwards and release the colour so it can spread. Add some water with the same brush to dilute the colour and create a gradation. Collect the excess at the bottom of the paper, soaking it up on the kraft paper with a clean sponge. Then use the atomizer to redirect the colour and put the finishing touches to the gradation.

●●● 3 Add some cypress green to the ruby red deep. With the fine wash brush, lay the resulting brown shade on the part of the strawberry which is in shadow on the right. Tilt your board to spread the colour. Mark the shadows of the seeds next to the white reserved areas by pressing the point of the wooden skewer into the paper so that the pigments settle there.

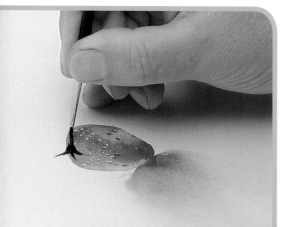

●●● **4** Squeeze out your no.7 brush, flatten it in the shape of a spatula and pass it over the parts of the strawberry that are in the light to lift out some paint and create highlights. Work the top part of the reflection in the same way. Moisten the reflection of the strawberry with the brush and refine its shape. Absorb the excess water at the bottom of the paper with a sponge. To finish, paint the strawberry stalk in cypress green using the fine sable hair brush. Clean your equipment.

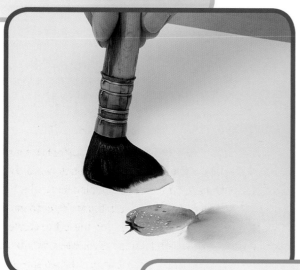

●●● **5** Prepare a good quantity of cypress green and raw umber mixed together on your palette. Also put some lemon yellow and some ruby red on the palette without mixing them. With the no.10 wash brush, draw the shape of the pear on the right in clear water. For the round parts, hold the brush vertically and make it swivel like compasses, flattening the hairs. Refine the contours of the pear with the finer wash brush. Tilt the board to distribute the water well over the whole design and soak up the excess with a clean sponge.

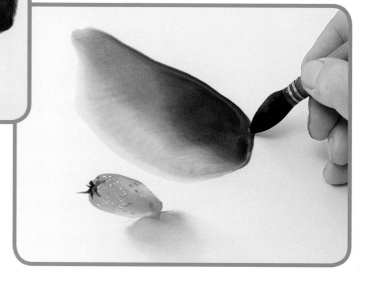

●●● **6** With the rounded handle of a brush, mark the bruised parts of the pear in the paper so that the paint will subsequently settle in them. Load your no.7 wash brush with yellow. Lay the colour on the left part of the pear, then tilt the board to make it spread. Next lay the mix of green and umber at the bottom of the pear and tilt the board to spread it on the right and then towards the centre, so the two shades mix. Absorb the excess wash on the right using the squeezed out brush until the colours become lighter.

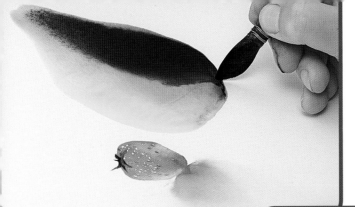

7 Now mix the umber with a very small amount of cypress green and lay the colour in the centre of the pear. Tilt the board to spread it to the right and take up the excess with the brush.

8 Draw the reflection of the pear in clear water using the no.10 brush. Then tilt the board and release the area at the bottom of the pear so the colour bleeds into it. Soak up the excess on the kraft paper with a clean sponge. Then add some water to the wash brush and dilute the shade, creating a gradation. Refine the gradation using the atomizer, as at step 3.

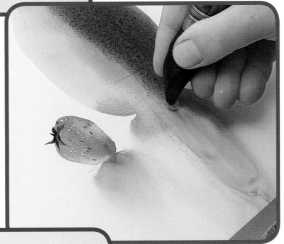

9 Warm up the colours by laying some Persian red light on the right of the pear. Tilt your board downwards and spray it to shade off the colour, guiding it into the reflection. With a squeezed out wash brush flattened into a spatula shape, lift out some colour on the left to create highlights in the yellow and introduce volume. Continue to work the reflection, adding water to make the red spread through it. Finish by thinning down the colours with the atomizer. Allow the colour to drain downwards and soak up the excess with a sponge.

10 Emphasize the shadow in the central part of the pear with a mix of red and raw umber laid on with the wash brush. Tilt your board to spread the colour. Wash and squeeze out your brush, then flatten it in the shape of a spatula and lift out some colour to bring light and volume to the base of the pear. Do the same thing two-thirds of the way up the pear to suggest the beginning of the fleshiest part. Soak the edge of a small piece of flat cardboard with the umber lightly tinted with green, and apply it with a curved stroke to represent the stalk.

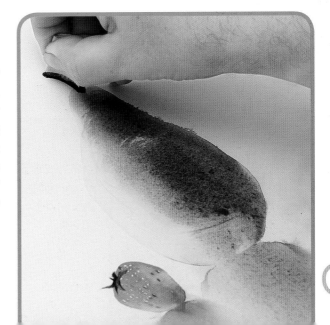

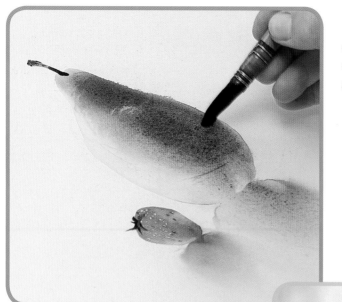

11 With the no.3 brush, squeezed out and flattened, continue the highlights and ease the passage of one colour to another, shading them into each other. Leave to dry.

12 Once dry, remove the dark edges that have formed around the fruit. To do this, pass the flat, moist brush around the outside edge of the pear to dilute the paint and then sponge it straight away with absorbent kitchen paper to remove it. This will give the pear volume. Clean your palette and materials.

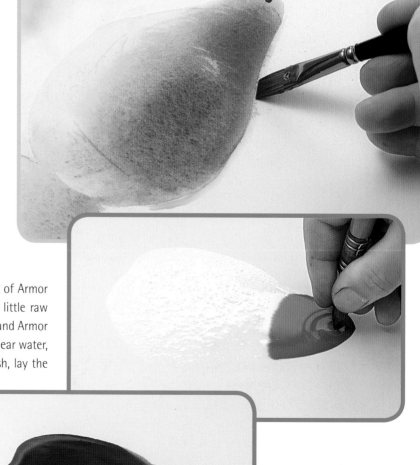

13 For the pear on the left, prepare a mix of Armor green and lemon yellow to which you will add a little raw umber. Prepare a second, darker mix of raw umber and Armor green. Now draw the shape of the second pear in clear water, proceeding as in step 7. With the no.7 wash brush, lay the first colour on the pointed part of the pear and the second on the fleshy part. Tilt the board to distribute the colours and reserve a white space in the centre for the splash of light.

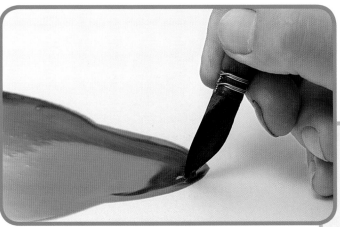

●●● **14** Keep tilting the board to direct the colours carefully according to the light and dark areas of the pear. To finish, allow the dark colour to run downwards and absorb the excess with the clean, squeezed out wash brush.

●●● **15** Add volume to the fruit by 'sculpting' some light areas. Squeeze out your no.7 brush and flatten it like a spatula; then pass it through the wet paint to lift it out in the places where the light falls and to suggest the rounded fleshy part. Next, shade one colour into another by gently stroking the paper with the same brush.

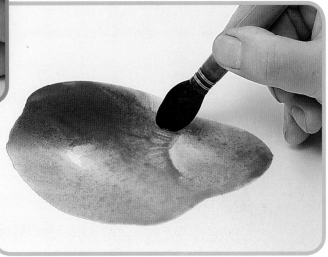

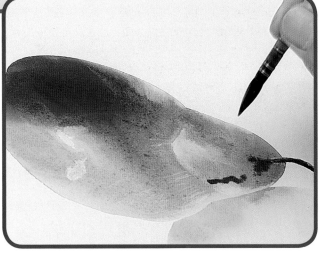

●●● **16** With the no.7 brush soaked in clear water, draw the shape of the reflection. Wait until the last moment to release the colour at the base of the pear and allow it to spread downwards. Catch the excess wash with a clean sponge, then using either the brush or the atomizer, refine the gradations in the reflection using the same method as for the other fruits. With the squeezed out and flattened brush continue to work on giving volume to the pear, lifting out colour on the edges. Finally, run the brush around the pear and its reflection to bring back a little of the white.

●●● **17** Soak the edge of a small piece of flat cardboard in umber lightly tinted with Armor green and apply it in a curve to represent the stalk of the pear. Paint the darker part on the left of the stalk with the same colour, flicking the brush. Shade out the colour using a clean brush and then lighten the rounded part around the stalk. With the rounded end of a brush handle make marks in the paper to suggest the blemishes and imperfections on the left side of the fruit. Leave to dry.

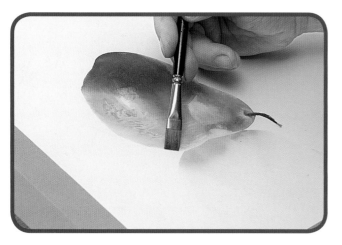

●●● **18** When dry, remove the dark lines that have formed on the outside edges of the pear by lightly brushing the paper with the flat moist brush and sponging it with absorbent kitchen paper, as in step 12. To give a grainy appearance to the skin of the fruit, lightly rub some paraffin wax on the left side, then moisten it with a brush and wipe it away immediately with absorbent kitchen paper. Clean your palette.

●●● **19** Dilute some blue grey on your palette. With clear water, moisten the shape of the shadows cast by the fruits on the right with a wash brush. Absorb the excess water with a brush. Lay the blue grey on the left and tilt the board to spread it towards the right up to the edge of the paper. Soak up the excess on the kraft paper with a sponge. Create some highlights and soften the shadow by lifting out some colour in the wet using the clean brush, squeezed out and flattened in the shape of a spatula.

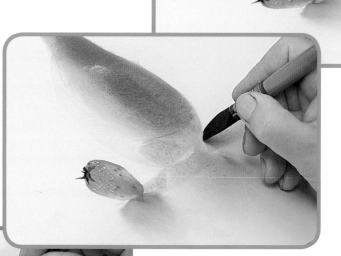

●●● **20** Paint the shadow cast by the pear on the left in the same way, adding a little umber to the blue grey. This time absorb the excess with a clean brush as you cannot drain it away at the edge of the paper. Add more detail to the pear by brushing the paper lightly with the flat, moist brush and then sponge it away immediately with absorbent kitchen paper. This will lift out some colour just to the left of the stalk and create texture. Darken the tip of the stalk with umber, laid on with the very fine sable hair brush.

●●● 21 Finish your composition by highlighting the shadows beneath the fruits. Mix some umber with cypress green and a little blue grey. Lay the colour on from left to right beneath the first pear and allow it to spread gently into the grey shadow already painted. Soften the gradation with a medium wash brush. Repeat the process for the other two fruits.

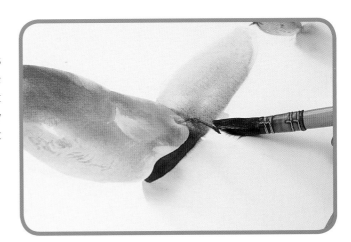

●●● Variation

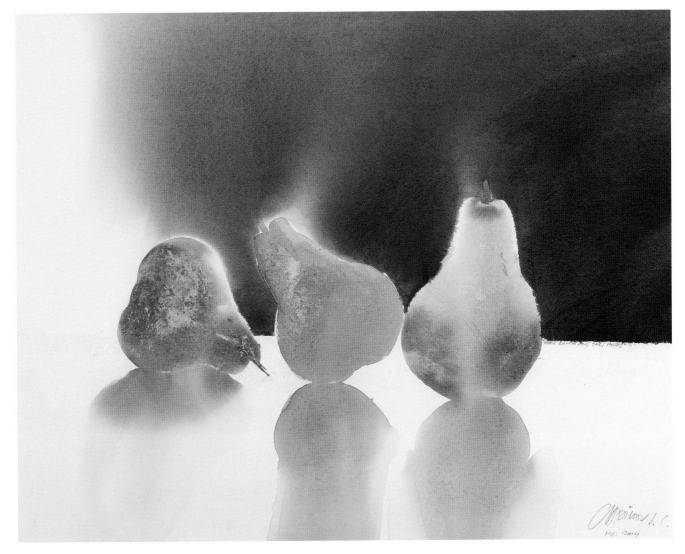

Three pears in the light
I often position the fruits that I paint in a row, as though they were comedians on a stage, lit with imaginary footlights. It really brings them to life.

●●●The forgotten basket

This painting is a good excuse for playing with light based, essentially, on values (different gradients of the same colour). The colours are simplified to create dramatic intensity, whilst the detail of the weaving creates a balance with the areas left in the half-light.

Palette
- Lemon yellow
- Persian violet
- Cypress green
- Ultramarine blue deep
- Raw umber

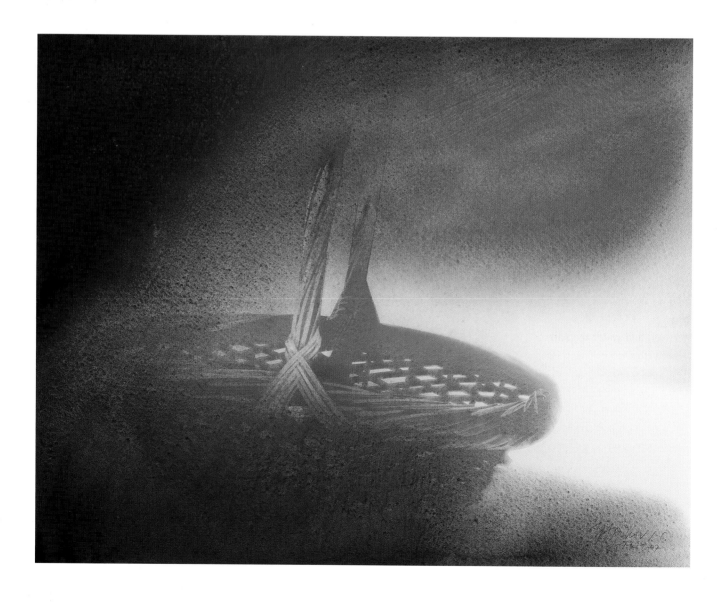

Materials

Paper 65 x 50cm (approx.20x26 in) stretched over board:
Arches Lavis Fidélis 220g/m² (140lb)
Hogs hair brush for mixing colours on the palette
Squirrel hair wash brushes no.7 and no.3
Riggers of different sizes
No.12 flat synthetic Kaërell brush
Atomizer
Piece of flexible plastic (Plexiglass type)
Absorbant kitchen paper
Sponges

●●● **1** Dilute a good quantity of ultramarine blue on your palette. Add some lemon yellow and then some Persian violet to one part of the blue to obtain a reddish-brown. Soak a sponge with this colour and put it to one side on the palette.

●●● **2** Take the no.7 wash brush and draw the ellipse corresponding to the top of the basket in clear water. Gradually widen the movement and keep adding more water until the surface of the paper is swollen. Distribute the water evenly over the whole ellipse by gently tilting the board. Then draw the excess water in the ellipse downwards with a rigger to draw the vertical parts of the basket and the base line.

●●● **3** Load your no.7 brush with water again and draw the handle. Use a rigger to represent the diagonal lines of the wickerwork, making them extend slightly on the left and the right. Don't forget the upper part in the centre of the ellipse. Using the no.3 brush, broaden the strokes to leave only small white reserved areas and add water regularly to keep the design wet. To finish, sponge a good amount of water on at the base of the handle, then tilt the board to distribute it throughout the design. Absorb the excess with the sponge without touching the paper.

●●● **4** Immediately apply the paint in the sponge you prepared earlier to the centre of the basket. Tilt the board so it spreads throughout the whole design, without particularly emphasizing the handle.

●●● **5** Add some ultramarine blue to the rest of the brown on your palette. Soak another sponge with this colour and lay it on at the bottom of the handle, tilting the board so that the colour runs upwards.

●●● **6** Next, tilt the board more vertically to make the colour run downwards. Moisten the bottom of the basket with the atomizer to release the colour which will run down and form the shadows cast. Continue to work the shadows, pushing the colour back with the atomizer to create gradations whilst also saving some areas for light. Soak up the excess on the kraft paper regularly using a sponge.

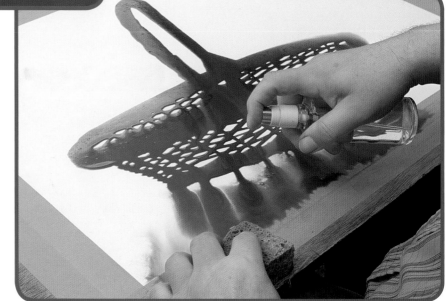

●●● **7** Wrap some absorbant kitchen paper around a piece of flexible plastic. Press it against the handle, lifting out the still-wet colour to evoke the weave. Use fresh paper as necessary.

●●● **8** Take up the shadows cast beneath the basket by spraying them with water again. The colours will become lighter as they wash off. Absorb the excess on the kraft paper with a sponge.

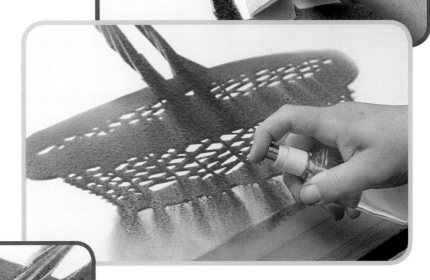

●●● **9** Squeeze out the clean no.7 brush by flattening it out in the form of a spatula. Pass it over the handle to lift out some colour and reveal some white spaces for highlights. Continue working on area where the handle meets the basket and the rim, then work on the texture of the wicker. Squeeze out the brush regularly and wash it. Carry on in this way, refining the details as you go. Leave the paper to dry.

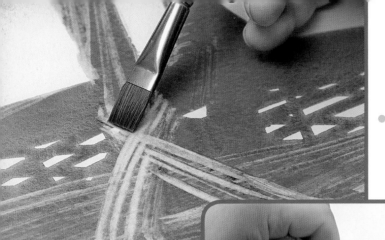

10 Emphasize the detail of the weave by highlighting the overlapping strands at the point where the handle is bound to the basket. Lightly brush the paper with the flat, moist brush to water down the colour in areas where the light falls. Then lift the colour out straight away by dabbing it with absorbant kitchen paper.

11 Deposit the colour left in the sponges on the palette. Mix them together and add some cypress green to obtain a slightly greenish brown. Soak another sponge with this colour and put it to one side. Now moisten the lower half of the composition with the atomizer and wipe the kraft paper at the bottom with a clean sponge to absorb the excess water. Immediately add the colour in the sponge to the left part of the basket. Tilt the board to distribute the colour throughout the whole basket, including on the shadows.

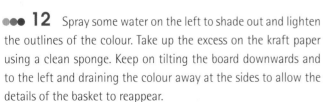

12 Spray some water on the left to shade out and lighten the outlines of the colour. Take up the excess on the kraft paper using a clean sponge. Keep on tilting the board downwards and to the left and draining the colour away at the sides to allow the details of the basket to reappear.

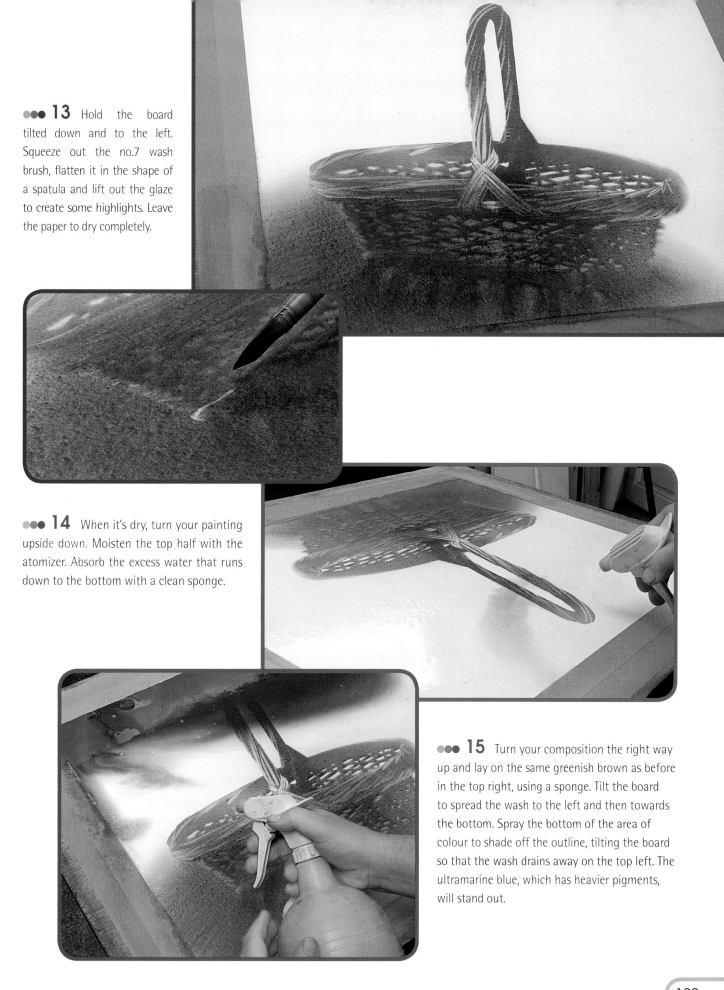

●●● **13** Hold the board tilted down and to the left. Squeeze out the no.7 wash brush, flatten it in the shape of a spatula and lift out the glaze to create some highlights. Leave the paper to dry completely.

●●● **14** When it's dry, turn your painting upside down. Moisten the top half with the atomizer. Absorb the excess water that runs down to the bottom with a clean sponge.

●●● **15** Turn your composition the right way up and lay on the same greenish brown as before in the top right, using a sponge. Tilt the board to spread the wash to the left and then towards the bottom. Spray the bottom of the area of colour to shade off the outline, tilting the board so that the wash drains away on the top left. The ultramarine blue, which has heavier pigments, will stand out.

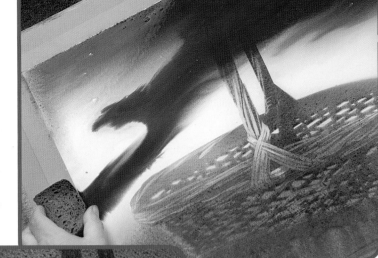

●●● **16** Lay some more colour on and distribute it to create a half-light above the basket. Shade off the outline with the atomizer. Working with the wet colour, pass the squeezed out no.7 wash brush, flattened into a spatula shape, over the base of the handle and the rim of the basket to reveal the highlights again. Dab with absorbant kitchen paper to remove the colour.

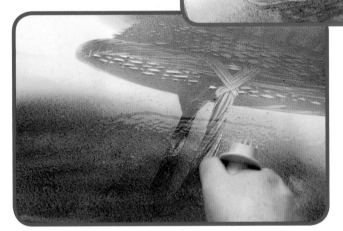

●●● **17** If halo effects appear, spray the area concerned to push the pigments back and create a fine gradation, holding your composition upside down. Absorb the excess water on the kraft paper with a sponge. Leave the paper to dry completely. In the meantime, wash your equipment. If halo effects persist when the composition is dry, remove them by lightly brushing the paint with a flat moist brush to dilute it, then dab it with absorbant kitchen paper to remove them.

●●● **18** A final glaze will accentuate the contrast between the areas filled with light and those plunged in darkness. Mix together raw umber and ultramarine blue deep. Soak a sponge with this mixture and put it to one side. Moisten the whole paper with the atomizer, then drain the excess water towards the sides and absorb it using a clean sponge. Now lay the colour in the sponge in the top left-hand corner and tilt the board to spread it over the left part of the basket and below. Absorb the excess at the sides. Add more colour below the basket as necessary.

19 Spray with water to soften the contours of the glaze and bring out the weave of the basket. To finish, leave the whole paper to dry completely before sealing your painting with fixative.

●●● Variation

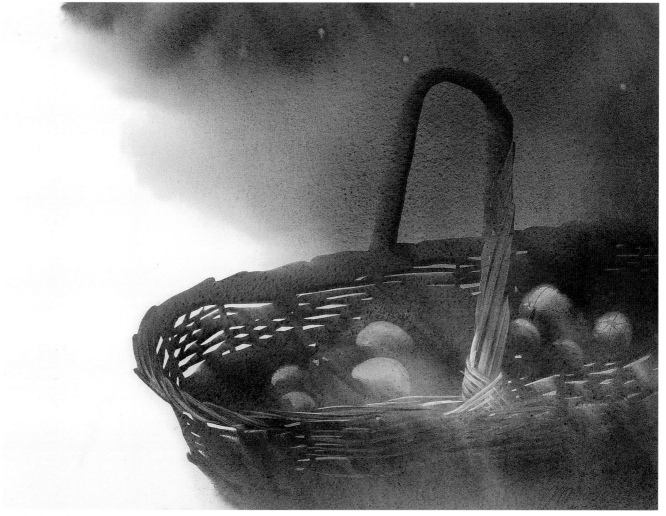

The basket of potatoes
I find the half-light of a storeroom very interesting. It's an environment where time silently stands still. We tend not to pay enough attention to the simple things in life and I wanted to show their everyday beauty.

Misty panorama

A damp, misty day... The first steps, when the washes were laid on, had to be carried out quickly so the water didn't have time to evaporate. Perspective was created using soft shades that did not contrast strongly with each other, allowing the viewer's eye to wander at its own pace.

Palette
- Lemon yellow
- Persian red light
- Carmine lake
- Raw umber
- Ultramarine blue deep
- Cypress green
- Persian violet
- Blue grey

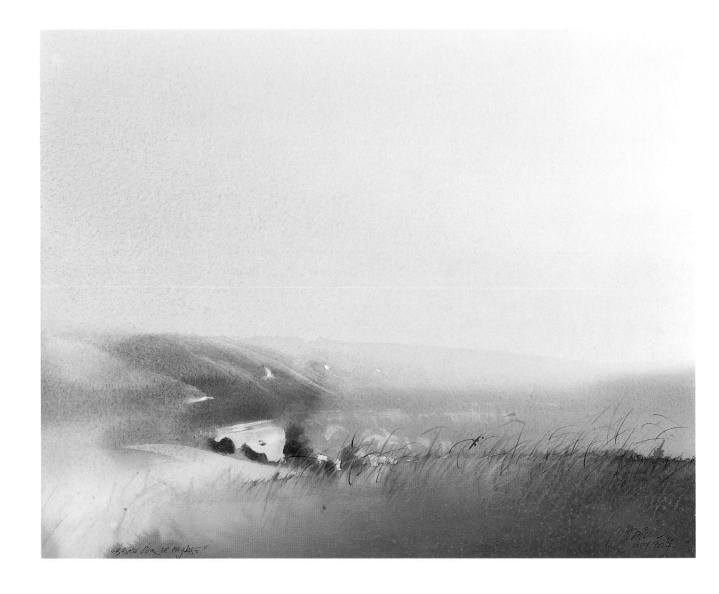

Materials

Paper 65 x 50cm (approx.20 x 26in) stretched over board:
Arches Lavis Fidélis 220g/m² (140lb)
Hogs hair brush for mixing colours on the palette
Wash brushes no.7 and no.3
No.2 fine sable hair brush
No.12 flat synthetic Kaërell brush
Riggers of different sizes
No.40 synthetic spalter brush
String brush (see p.24)
Atomizer
Paraffin wax disc
Round piece of plastic
Absorbant kitchen paper
Flat abrasive sponges
Sponges

Preparation

Prepare a very diluted mix of blue grey and lemon yellow for the cliffs. Soak a sponge in this colour and put it to one side on your palette. For the forest below, add some Persian violet to the colour remaining on your palette and then enrich it with some ultramarine blue deep. The ultramarine will precipitate as it dries, giving an authentic looking grain to the body of trees. Finally, add some cypress green and a little Persian violet. Soak a second sponge in this mix and put it on one side. Now prepare a brighter green for the grassy part in the foreground by adding water and then some yellow to the remaining colour on your palette. Soak a third sponge and put it to one side.

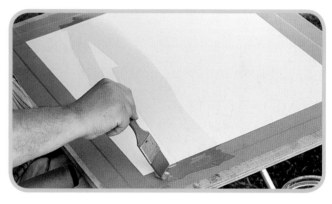

●●● 1 Draw the main lines of the landscape in clear water with the spalter brush, leaving the river area untouched. Add water to your drawing with a sponge to wet the paper thoroughly. Tilt the board to spread the water throughout the whole drawing down to the bottom of the paper.

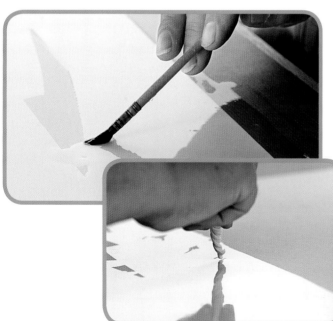

●●● 2 Take the no.3 wash brush and put in the jagged cliff tops and the edge of the water below in order to position the trees on the side where you are sitting. Tilt the board again to drain off the excess water on the sides and soak it up on the kraft paper with the sponge. Create some highlights in the white parts of the cliffs using a twisted piece of absorbant kitchen paper.

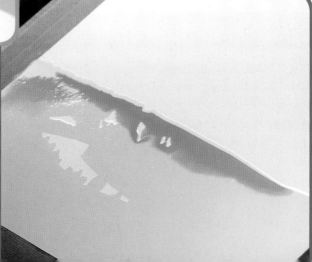

●●● 3 Lay the blue grey mix in the first sponge above and to the left of the cliffs. Tilt the board to distribute the colour throughout the cliffs and then towards the bottom of the paper. Absorb the excess with a sponge.

●●● 4 Take the second sponge with the darker mix and lay the colour over the first one where the forest is, on the right of the river. Tilt your board to the right to drain away the excess water and colour and soak it all up with a sponge. Repeat, laying on the colour with the no.7 wash brush to create a darker strip. Then drain off the excess to the right.

●●● 5 Keep laying this colour on with the brush, left of the loop in the river and guide it towards the right to fill the jagged line of the trees at the water's edge. Add the clumps of trees with the brush and start to represent the reflections in the river.

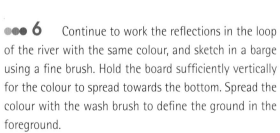

●●● 6 Continue to work the reflections in the loop of the river with the same colour, and sketch in a barge using a fine brush. Hold the board sufficiently vertically for the colour to spread towards the bottom. Spread the colour with the wash brush to define the ground in the foreground.

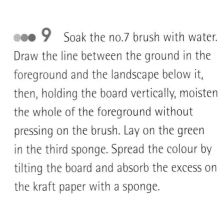

7 Wrap a small piece of abrasive sponge in a sheet of absorbant kitchen paper. With a confident action, draw the ploughed fields below in the wet.

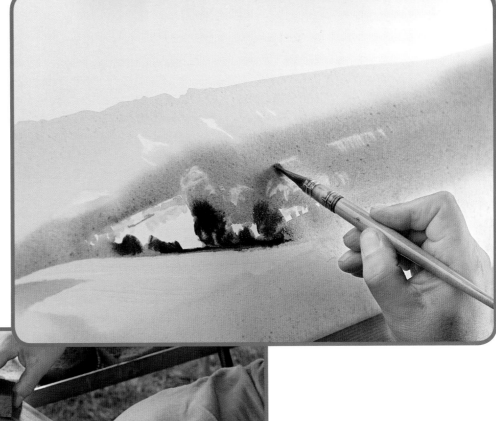

8 Add some cypress green and Persian violet to the colour of the second mix. Then, with the no.7 brush, strengthen the groups on the left bank of the river. Rinse your brush, squeeze it out and flatten it in a spatula shape to 'sculpt' the wet colour: lift out some of the colour and introduce light into the trees of the forest on the other side.

9 Soak the no.7 brush with water. Draw the line between the ground in the foreground and the landscape below it, then, holding the board vertically, moisten the whole of the foreground without pressing on the brush. Lay on the green in the third sponge. Spread the colour by tilting the board and absorb the excess on the kraft paper with a sponge.

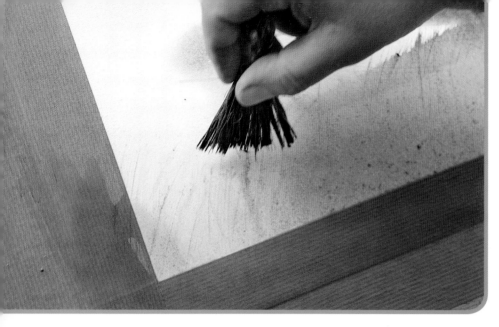

●●● **10** Load the string brush with the same colour that you used for the trees. Run it through the still-wet green using hard strokes to denote the tall grasses in the foreground. Refine the details with a moist, clean rigger. Collect the excess water at the bottom of the paper as necessary to prevent a halo effect. Leave to dry completely.

●●● **11** Mix some grey blue with the remaining green on your palette. Soak a sponge with the mix and put it on one side. Without rinsing the palette, add some ultramarine blue deep, carmine lake and a little Armor green to obtain a bluish grey verging on violet. Soak a sponge with this second mix and put it on one side. Use a bit of this last mix to sketch out a second barge using the fine sable brush.

●●● **12** Moisten the cliffs and trees with the atomizer. With a twisted piece of absorbant kitchen paper, lift off the water on the white rocks of the cliffs, then rub paraffin wax on them to create highlighted areas and preserve them from the glaze to come.

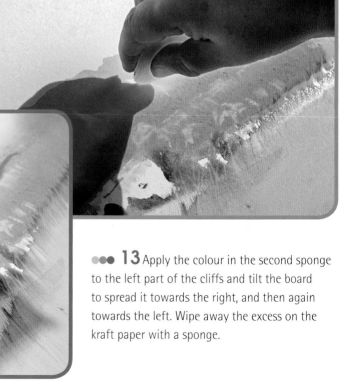

●●● **13** Apply the colour in the second sponge to the left part of the cliffs and tilt the board to spread it towards the right, and then again towards the left. Wipe away the excess on the kraft paper with a sponge.

●●● **14** Spray the whole landscape except for the sky and then lay the same colour on the cliffs in the centre of the composition. Tilt your board to spread it towards the left this time, avoiding the river. Absorb the excess on the kraft paper with a sponge. Lighten some areas using the atomizer.

●●● **15** 'Sculpt' some lighter areas in the cliffs by sweeping a squeezed out brush, flattened in the shape of a spatula, over them to lift out some colour and bring out the blue pigments. Then spray them with the atomizer. Work the reflections of the river again and bring back some white on the boats by absorbing the colour with the flat brush. Leave to dry completely.

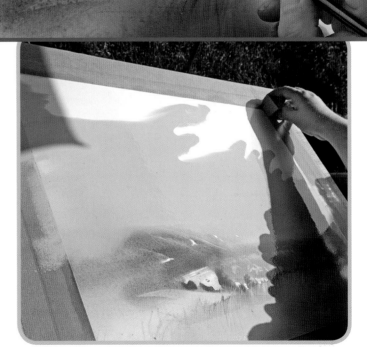

●●● **16** Laying a milky glaze over the whole landscape will give a misty atmosphere to the painting. Protect the river with paraffin wax. Use the spalter brush for watering down the sky and the atomizer for the rest of the landscape. Drain off the excess at the sides and absorb it on the kraft paper with a clean sponge. Add more water to the paper. Take the first sponge soaked in blue grey and put the colour well over to the right of the composition, where the trees meet the sky. Tilt the board to distribute it across the whole sky.

●●● **17** Spray the foreground with water and let the colour spread down to the bottom of the paper. Drain away the excess colour straight away, tilting your board in all four directions, and absorb it on the kraft paper with a sponge. Highlight the cliffs using the atomizer. 'Sculpt' them again with the squeezed out no.7 brush and leave the glaze to dry.

●●● **18** Before the sky is dry, create a few grasses in the foreground by scratching the paper with the plastic disc. Make them run into the landscape below. The sharpness of these lines against the softness of the landscape will increase the effect of perspective.

●●● **19** Add some Persian red and lemon yellow to the remaining bluish-grey to obtain a mustard colour you can use to suggest the grasses with the very fine sable brush. Add some raw umber to the mix and paint the tips of the grasses. Leave to dry completely.

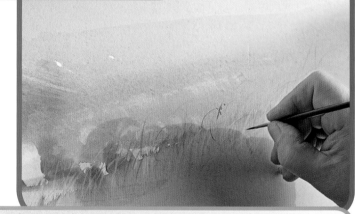

●●● **20** When dry, spray the foreground and apply a final glaze made up of lemon yellow, Persian red light and cypress green mixed together. The contrast between these warm shades and the cool shades in the distance will increase the effect of perspective. To finish, remove the paraffin wax using a hairdryer and absorbent kitchen paper.

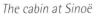 Variations

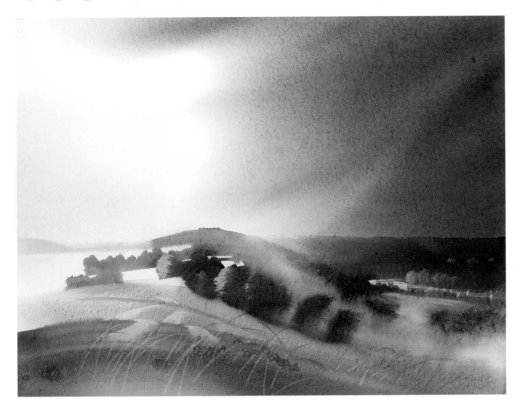

Storm over Haute-Isle
Elements lose their colour in a storm. I tried to convey the impression of light in the still warm sky.

The cabin at Sinoë
What interested me in this scene was the sheet metal roof of the little cabin lost in the surrounding nature. I often hide what interests me most. It's fun to draw the viewer's eye elsewhere, towards the drops of water or the curves in the blades of grass.

●●● The snail

The colours here are deliberately washed-out to emphasize the feeling of slowness suggested by the snail and the bursting vitality of the vegetation. The composition of the painting and its use of light draws the viewer into a world of nature, usually hidden and rarely seen.

Palette
● Lemon yellow
● Persian red light
● Armor green
● Cypress green
● Blue ash
● Raw umber

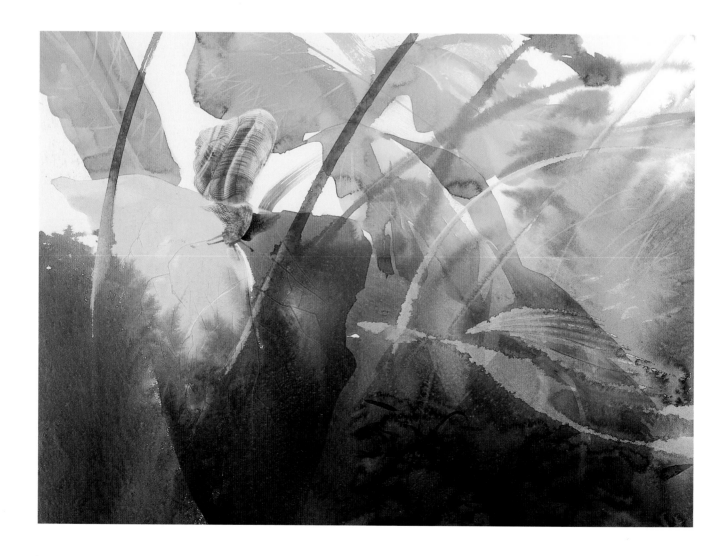

Materials

Paper 65 x 50cm (approx.20 x 26in) stretched over board:
Arches Lavis Fidélis 220g/m² (140lb)
Hogs hair brush for mixing colours on the palette
Squirrel hair wash brushes no.7, no.3 and no.2-0
Riggers of different sizes
No.2 fine sable hair brush
No.12 flat synthetic Kaërell brush
No.40 synthetic spalter brush
String brush (*see* p.24)
Atomizer
Paraffin wax disc
Fine-tooth comb
Small pieces of flat cardboard
Small flat piece of wood
Piece of flexible plastic (Plexiglass type)
Round piece of plastic
Absorbant kitchen paper
Sponges

Preparation

Soak the small piece of wood in water. Poplar wood is ideal because it doesn't contain any resin. It is very supple, swells quickly and has good capillary action.

●●● **1**　Decide where to place the snail in your composition and then draw the shape of the shell with clear water using the no.7 wash brush. Define the contours with a finer wash brush. Mark the different parts of the shell in the moist paper with the plastic disc. Then mark the striations of the shell with a fine-tooth comb. Redistribute the water by tilting your board and absorb the excess with a squeezed-out brush.

●●● **2**　With the no.7 brush, lay a mix of raw umber and lemon yellow on the shell. Spread it by tilting the board and absorb the excess with the brush.

●●● **3**　Roll a sheet of absorbant kitchen paper over the edge of a piece of flexible plastic. Place it on the rounded parts of the shell to create light areas which will introduce volume. Absorb the surplus colour with the squeezed-out no.7 brush.

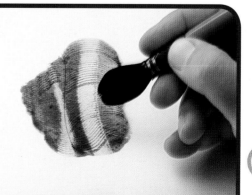

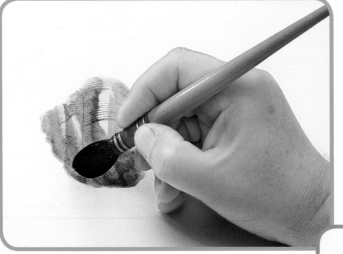

●●● **4** Touch the paper lightly with a fine wash brush loaded with raw umber to create some darker areas. Lift out the colour with the moist brush to create some intermediate tones. Then take the no.7 brush again, squeeze it, flatten it out in a spatula shape and lift some colour out here and there.

●●● **5** Draw the first part of the snail's body with clear water and allow the colour from the shell to spread into it. Continue to work on the volume of the shell by 'sculpting' the colour to bring in some areas of light: lightly pass the flat moist brush over the areas to be highlighted to dilute the pigments, then dab them straight away with dry absorbant kitchen paper to lift out the colour. Repeat the operation as many times as necessary.

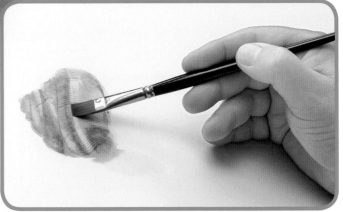

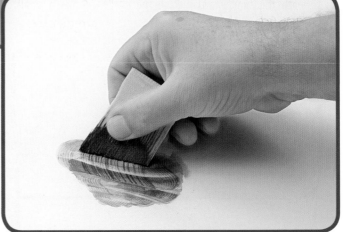

●●● **6** Rub areas with wax for highlights. Mix together some Persian red, raw umber and a little yellow. Lay some of this blend on the shell with a small wash brush. Absorb the excess with a brush.

●●● **7** Score the edge of the piece of wood you've soaked in water with a cutting knife. Soak it in the mix of raw umber and yellow and draw the striations on the shell, following the rounded lines creating the volume. Leave to dry.

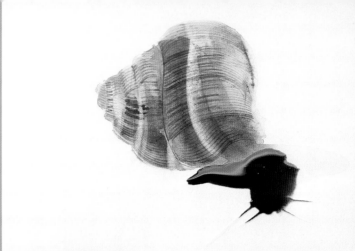

●●● **8** Using clear water, draw the shape of the snail's body with a fine wash brush and then the tentacles with a very fine sable brush. Absorb the excess water. Mix together some Armor green, raw umber and a little Persian red light. Put this colour on using the no.7 brush and tilt your board so it spreads through the whole body and the tentacles. Absorb the excess with the squeezed-out brush.

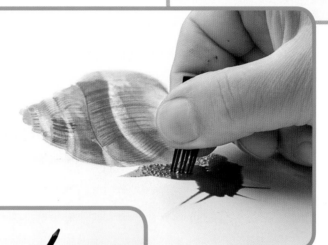

●●● **9** Tap the colour you've just laid down with a small fine-tooth comb to represent the grainy texture of the body, a bit like meshing. Absorb the excess colour with the brush and add a few more details with the comb. Mark the eyes with the very fine sable brush. Leave to dry. Soften some parts of the shell as necessary using the flat moistened brush. Leave to dry and clean your palette.

●●● **10** With the no.7 brush, draw a large leaf in clear water underneath the snail, starting with the outline. Cover a small piece of flat cardboard with absorbant kitchen paper and draw the veins of the leaf. Mark the secondary veins in the paper with the plastic disc. Then drain the excess water away at the bottom of the leaf and soak it up with a clean sponge.

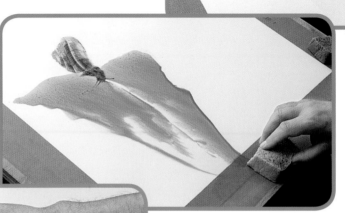

●●● 11 Mix together a good quantity of cypress green and blue ash. Soak a sponge in it and lay the colour at the top of the leaf on either side of the central vein. Tilt the board to spread the colour through the whole leaf. Drain the excess away downwards and soak it up on the kraft paper with a sponge.

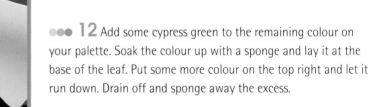

●●● 12 Add some cypress green to the remaining colour on your palette. Soak the colour up with a sponge and lay it at the base of the leaf. Put some more colour on the top right and let it run down. Drain off and sponge away the excess.

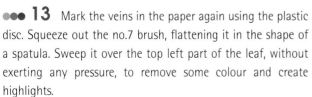

●●● 13 Mark the veins in the paper again using the plastic disc. Squeeze out the no.7 brush, flattening it in the shape of a spatula. Sweep it over the top left part of the leaf, without exerting any pressure, to remove some colour and create highlights.

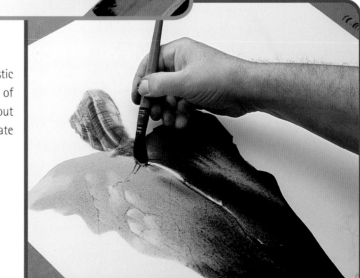

●○● **14** Soak the edge of a small piece of wood in the same dark green. Then, with a quick, vigorous movement, evoke the stems of the leaves nearby.

●○● **15** Take your spalter brush and begin to paint the other leaves with the different green mixes on your palette. Use gentle strokes with the brush from the top of the leaf to the bottom, creating both upstrokes and downstrokes that will allow you to lay on differing amounts of paint. Carry on painting the leaves in this way, adding a little cypress green to the mixes as you go.

●○● **16** Squeeze out the no.7 brush and lift out some colour from the leaves on the right and from the veins of the large leaf on the left, creating lighter areas.

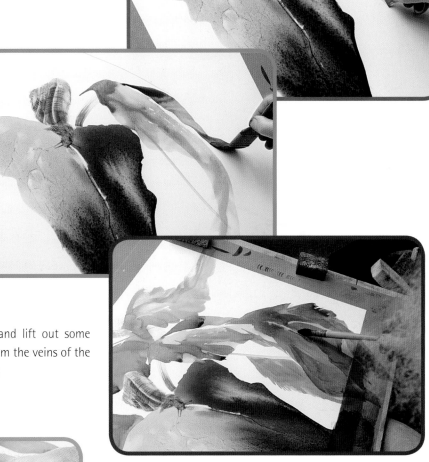

●○● **17** Mark a few veins with the rounded end of a brush handle so the colour that's still wet settles there. Then bring in some areas of light by brushing the paper with the flat moist brush to lift out the colour here and there. Play on the contrast between the fine details of some parts and the less defined nature of others. The composition will be all the more vibrant for it. Leave to dry thoroughly.

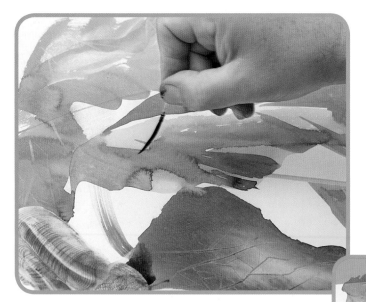

18 Paint the shadow cast by the snail using a wash brush and a mix of cypress green and blue ash. Draw some veins on the leaves on the left using clear water and a rigger, then lift out the colour straight away, rubbing dry absorbant kitchen paper over it without dabbing. Leave to dry.

19 Laying on a glaze will create the illusion of thick vegetation on the ground. Make up the colour with a good quantity of cypress green and a little blue ash. Soak a sponge in it and put the sponge to one side. Wet the paper well with the atomizer. Draw some wild grasses between the leaves on the right using the string brush and clear water so the colour of the glaze can spread into them. Drain the excess water away at the sides and absorb it with a clean sponge.

20 Lay the colour in the sponge at the bottom and in the centre of the composition without delay. Tilt the board to spread the colour to the right. Absorb the excess on the kraft paper with a clean sponge. Now tilt the board diagonally to direct the colour to the top left. Lay some colour in the lower left corner of the composition and spread it towards the top. The water in the pattern of grasses drawn with the string brush should run from the bottom to the top.

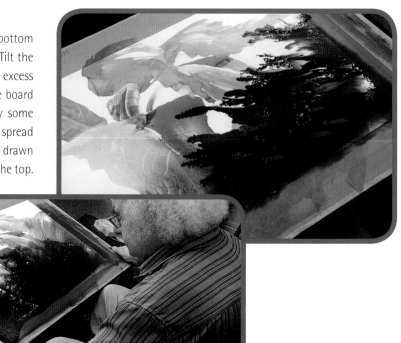

●●● 21 Using the same colour, paint some tall grasses in one movement using a rigger. Add a few darker leaves to the foliage on the right, applying some cypress green with a brush. With the edge of a piece of flat cardboard wrapped in absorbant kitchen paper, sketch in some tall grasses and a few leaves by lifting out some colour. These light areas balance the composition and allow the eye to move to the right without focusing the attention on the snail. Lift out a line of colour in each of the tall upright grasses in the same way.

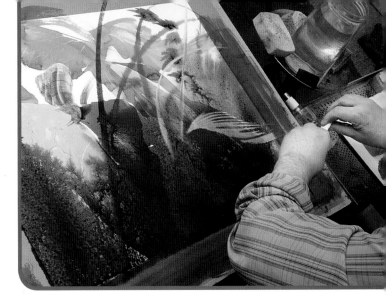

●●● 22 Continue to work on the details in this part, creating lines by lifting out colour with the rigger and introducing small areas of light with the wash brush.

●●● 23 Now brighten the foliage lower down by applying some cypress green with a flat brush, a wash brush and a rigger to achieve a richness of substance. Allow to dry.

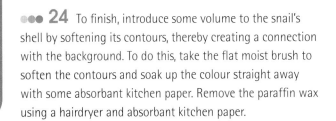

●●● 24 To finish, introduce some volume to the snail's shell by softening its contours, thereby creating a connection with the background. To do this, take the flat moist brush to soften the contours and soak up the colour straight away with some absorbant kitchen paper. Remove the paraffin wax using a hairdryer and absorbant kitchen paper.